HULL PUBS

PAUL CHRYSTAL

AMBERLEY

For John White and Les Almond,
my tireless research assistants.

Les on the left, John on the right.

O Yorkshire, Yorkshire: Thy Ale is so strong
That it will kill us all if we stay long:
So they agreed a Journey for to make
Into the South, some Respit there to take.
George Meriton, *The Praise of Yorkshire Ale*, 1684

There is nothing which has yet been contrived by man, by which so much happiness is
produced as by a good tavern or inn.

Dr Johnson (1709–84)

When you have lost your inns, drown your empty selves, for you will have lost the last
of England.

Hilaire Belloc (1870–1953)

First published 2017

Amberley Publishing
The Hill, Stroud
Gloucestershire, GL5 4EP

www.amberley-books.com

Copyright © Paul Chrystal, 2017
Maps contain Ornance Survey data.
Crown Copyright and database right, 2015

The right of Paul Chrystal to be identified as
the Author of this work has been asserted in
accordance with the Copyrights, Designs and
Patents Act 1988.

ISBN 978 1 4456 6854 3 (print)
ISBN 978 1 4456 6855 0 (ebook)

British Library Cataloguing in Publication Data.
A catalogue record for this book is available from
the British Library.

Origination by Amberley Publishing.
Printed in the UK.

Contents

	Map	4
	Acknowledgements	6
	Introduction	7
Part One	The Pubs	12
	Hull Brewing	65
	The Guest Pub	68
Part Two	The Lost Pubs of Hull	71
	List of Pubs and Breweries	92
	Further Reading	94

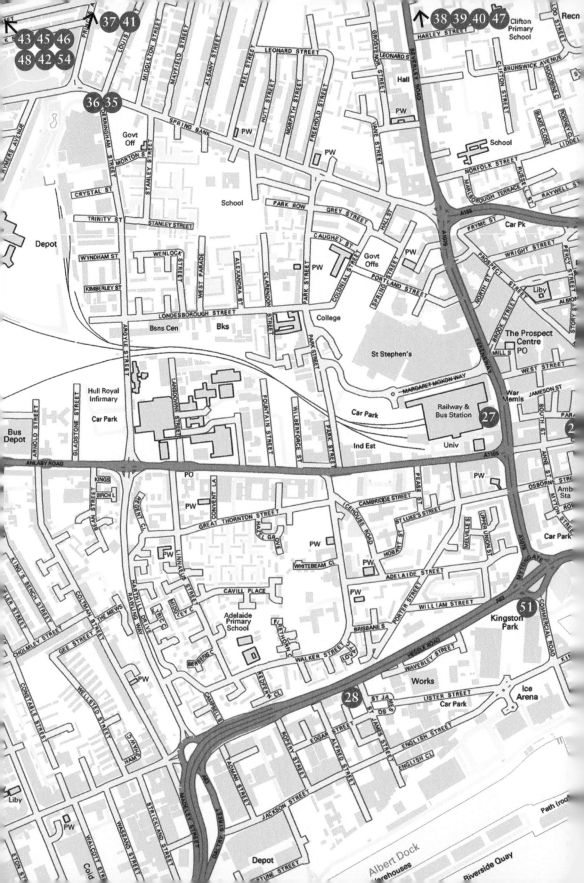

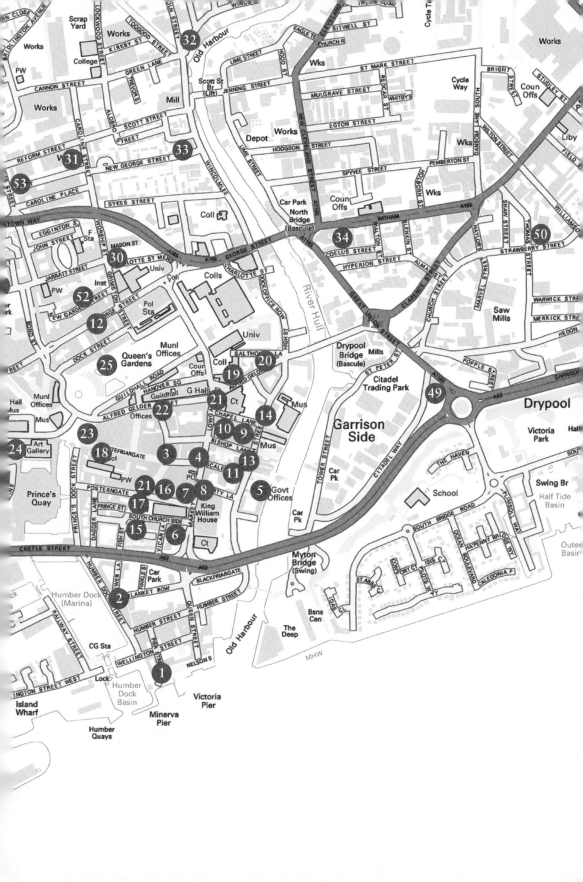

Acknowledgements

A book like this is always a joint enterprise between the author and the people who populate the subject matter – in this case the landladies and landlords, managers, hosts and hostesses, barmen and barwomen of the alehouses, taverns, inns, pubs and breweries featured here. Without their help this book would be just another arid listing of places to go for a drink or perhaps a meal. So I would like to thank them all (and in particular Adam Scruton at Ye Olde Black Boy) for their help and contributions, for sharing their knowledge of the history and heritage of their drinking establishments and for allowing me to take photographs and infuse this book with a plethora of interesting facts, fiction, traditions and anecdotes.

By the same author

Harrogate Pubs including Knaresborough
Historic England: Hull
Historic England: Leeds
Historic England: York
Hull in 50 Buildings
Pocklington Through Time
York in the 1970s
York in Picture Postcards

Introduction

Pubs and their names, like the names of towns and villages, hills, rivers and mountains, tell us much about the local history in the vicinity, the local people and the local topography. Here is a selection of some of the more interesting pubs in Hull, all with a tale to tell. Some are thriving, others are long gone, but their memories are just as important as those whose doors remain open.

In the beginning, alehouses or pubs often brewed their own ale in brewhouses next to the pub; women such as Madam Bradley of Northallerton and Nanny Driffield of Easingwold did much of the work in their own brewhouses. 'Brewsters' or 'alewives' brewed ale in the home for domestic consumption and commercial sale, albeit on a small scale. It was good ale that attracted neighbours into their houses and led to the birth of the public house. 'Stingo', 'Knockerdown' and 'Rumtum' were famous Yorkshire brews with reputations extending as far south as London's Marylebone. Hopped ale was imported from Flanders from around 1400, after which hops were grown in England for beer production – ale usually has a lower hop content than beer.

At the same time, hostelries were set up by the roadside catering for thirsty travellers. This had started with the Romans locating *tabernae* on their extensive empire-wide road network and continued apace with merchants plying between markets, long-distance drovers, commercial travellers, monks commuting from monastery to monastery, pilgrims and all manner of other people moving from village to village or from town to town. The lords of the manor sometimes provided beerhouse facilities for the workers in their fields. Ale was an important part of the Hull diet, being affordable and unpolluted compared to water. It is estimated that the average adult drank up to eight pints a day.

Things started to change in the seventeenth century when, in 1657, turnpikes led to a huge increase in the number of stagecoaches full of dry-throated passengers criss-crossing the country. Turnpikes demanded coaching inns for boarding and lodging for the drivers and passengers, and stabling for the horses, which required changing every 15 miles or so. Two hundred years later the railway brought the next seismic change with the establishment of railway inns at stations. The third development was the arrival of the motor car and the transportation of goods by road, which led to a need to cater for day-trippers, businesspeople, long-distance lorry drivers and other travellers – often in the same pubs that once served coach and railway commuters.

The first common brewers were the Nesfield family of Scarborough, established in 1691. The end of the eighteenth century saw the emergence in earnest of the common brewery; this was boosted by the Beerhouse Act in 1830 which enabled anyone to brew and sell beer on payment of a licence and saw the establishment of such names as John Smith's, Sam Smith's, Tetley's, Timothy Taylor's and Theakston's, all still going strong today. Beer brewing had moved out of the home and was now an industry in its own right, supplying a rapidly growing number of public houses and hotels.

The Beerhouse Act of 1830 saw licensed premises double in ten years, with 25,000 new licenses issued within three months of the legislation. It also galvanised the rise of the common brewery, brewing beer and selling it to other outlets rather than for oneself, family or neighbours. In 1823 Hull had 274 inns serving a population of 44,924, making a convivial ratio of one pub per 164 people.

One aim of the Beerhouse Act was to encourage people to drink beer rather than spirits. Any householder who paid the poor rate could sell beer, ale or porter by buying an excise licence – they did not a need a justices' licence like spirit-selling retailers. Beer sellers had to promise to give correct measures, maintain good order, to allow no drunkenness or gambling, and not to dilute the beer! However, not everyone warmed to the Act: many beerhouses emerged from the back streets of large cities and became working-class drinking dens. The *Leeds Mercury* of 23 October 1830 reported: 'We receive from many quarters grievous complaints of the demoralising effects of this Act, which has, by making beer cheap, led to an increase of intoxication.'

In 1897, a Dr Jackson in his submission to Hull magistrates on behalf of the Chief Constable regarding a licence renewal shone a numerical light on the situation:

> Bean Street in itself was 860 yards long and contains at present 17 licensed houses – 15 beer off licences, one fully licensed house and one beer-on-licence. If they took a radius of 20, 40 and 200 yards, they found one beer-off in every 20 yards, four in 40 yards and eight in 200 yards.

Pub signs are intriguing in their own right. The Romans started it all with a welcoming sign showing a bunch of vine leaves to denote a *taberna*. As with any other commercial enterprise, pubs used signs or symbols to signify the nature of the business and also because most people could not read until the end of the nineteenth century. Words would have been useless: a sign, however, spoke volumes: the barber's pole and the pawnbroker's balls still survive to this day. From 1393 it was the law for innkeepers to display a sign: pub owners accordingly invented names and signs to differentiate their hostelry from other inns and taverns in the locality; it might also advertise who or what might be found inside, or indeed the political leanings of the landlord. Coats of arms reflect the custom adopted by noblemen where they displayed their banners outside the inn to show that they might be found within. York's imposing gallows sign at *Ye Olde Starre Inne* spanning Stonegate is a rare surviving example of these literally unmissable pub indicators.

The name 'Royal Oak' indicated that the pub's proprietor was a supporter of Charles II (the king hid in an oak tree at Boscobel after the Battle of Worcester in 1651, before restoring the monarchy in 1660); 'Punch Bowl' revealed a Whig sympathiser; while 'Marquis of Granby' reflected the philanthropy of said Marquis. 'Chequers' denoted board games were available inside, while 'The Board' proclaimed that cold meats were on offer – the board being what the meats were served on, hence 'board and lodge'.

In 1553 the number of pubs was restricted by law: London was allowed forty, York a mere eight and Hull a miserable three. Legislation so universally ignored and unenforced would be hard to find: in 1623 there were still 13,000 licensed premises in England!

Hull, as elsewhere, had its fair share of pubs, inns, beerhouses and coaching inns. But Hull was noted for a particularly strong ale known as 'Hull Cheese', which fired the imagination of travellers and gave them a splendid reason to come and stay in the city. A merchant's business trip to Hull had definite benefits: so popular was Hull Cheese that the city later named a pub after it. In 1658 poet and MP Andrew Marvell was grateful for a 'cask of prime ale from Hull.' Tom d'Urfey's *Pills to Purge Melancholy* contains the poem 'In Praise of Hull Ale' 'sung' to the tune of *Greensleeves*; Pepys downed Hull ale in 1660. In 1661 naturalist Clayton Edward Ray agreed that 'Hull is noted for good ale' – and he should know: he was also the author of *The Wisdom of God Manifested in the Works of the Creation* (1691). There is little doubt that Philip Larkin would also have been in agreement.

As a consequence of the ubiquity and ready availability of ale, drunkenness was often rife and the archives of Hull are replete with repeated orders by the corporation for a cull on the number of alehouses; this reached its peak between 1566 and 1640, largely due to religious pressure, but none of the restrictions lasted very long.

Drink sometimes breeds and attracts vice, and the corporation agonised and wrung its collective hands over morality and prostitution, a trade exaggerated in this town with its 'systematic' prostitution of immigrant German girls; the transitory population of seamen, soldiers and travellers were seen as a serious threat to local morality. Pubs, where these itinerants gathered, fostered this. Unmarried mothers were dealt with severely – drinking was blamed for their immorality and on one occasion women were even threatened with penalties by the legal authorities for wearing extravagant clothes. Things came to a head at the close of the seventeenth century when the Society for the Reformation of Manners campaigned energetically against swearing and drunkenness.

In a bid to reduce immoral behaviour, Hull enjoyed the beneficence on offer from various institutions (which we might term charities today); some were educational, some philanthropic, including the Ragged Schools, the Mechanics' Institute, the Young People's Christian and Literary Institute, the Sailors' Home and Sailors' Institute, the Hull and East Riding Penitentiary for Fallen Women, the Temporary Home for Fallen Women and even the Society for the Relief of Really Deserving Foreigners. But the good works had to battle against the gig economy: casual labour in the docks, seasonal employment in shipping. According to T. H. Travis, a stipendiary magistrate, there were 306 brothels known to the police in 1869. For most Hull people the only opportunities for entertainment and recreation were Hull Fair once a year and the 309 gin shops and 287 beerhouses thriving in the town in 1869.

The main coaching inns at the end of the eighteenth century were the Cross Keys and the Rein Deer (Market Place), the Cross Keys (Whitefriargate), Moor's (Land of Green Ginger) and Welburn's (Lowgate). Only the Cross Keys and the Rein Deer remained of any importance by the 1830s, with the arrival of the steam train. Much of the coaching trade had by then gone to the Vittoria Tavern (Queen Street), the Bull & Sun (Mytongate) and the Black Horse (Carr Lane). The Black Horse was exceptional in that it maintained its coaching business as late as the 1860s.

Hull, of course, had its brewers, but in the 1850s and '60s about 80 per cent of the malt brewed in the Hull Excise Collection was handled by public brewers rather than by licensed victuallers – much more than was to be found elsewhere in Yorkshire.

Pubs were never just pubs. Many doubled up as coroners' and magistrates' courts, as markets, morgues and as brothels or smugglers' dens; others were also blacksmiths, cobblers or carpenters – often the landlord's day job. One of the most surprising was The Humber Tavern in Paull, east of Hull, where in 1836 Trinity House decided that 'lights be exhibited in the windows of a public house at Paull as a temporary expedient until the erection of permanent lights.'

Some of Hull's pub names are arcane and distinctly odd. We have mentioned the Hull Cheese; the Black Boy has nothing to do with slavery but relates rather to the premises' tobacco trade antecedents; Hull's Goat & Compasses is a corruption of the Puritan motto 'God encompasses us', while The Ravenser remembers the unfortunate village on the Humber swept away by the sea in 1346. The Four Alls in Cottingham Road derives from the four universal aphorisms: The king (or queen) rules for all; the priest prays for all; the soldier fights for all; the ordinary man or farmer pays for all.

Finally, just as any good pub worth its hops has a programme of guest beers so then shall this book feature a guest pub. A pub that is not actually in Hull but which might as well be, given the magnetic effect it exerts on Hull pub-goers, is just up the (Beverley) road in the medieval town of Beverley; it is of course The White Horse, more affectionately known as Nellie's.

In 1875 Yorkshire could boast some 10,000 pubs. Today there are significantly fewer, with time being called for the last time across the county. So, if there is a message to take from this book it is simply put the book down, go out and call in at your local for a pint or two and help preserve this most British of social institutions. Once your favourite pub has gone, it is usually gone for good. But do not just take it from me, for as Anglo-Frenchman Hilaire Belloc (1870–1953) said: 'When you have lost your inns drown your empty selves for you will have lost the last of England.'

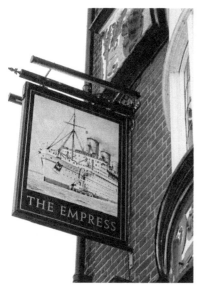

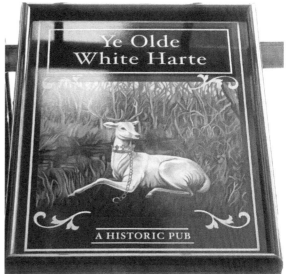

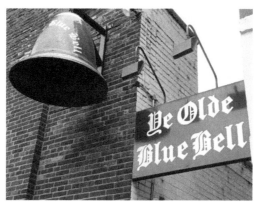

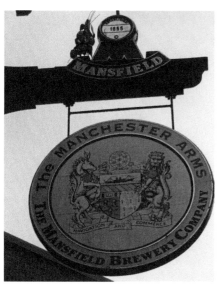

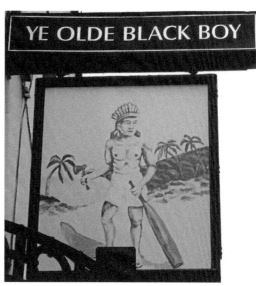

Part One

The Pubs

1. The Minerva, Nelson Street, Hull

This was the pub of choice during Hull's days as a premier fishing port. It is located in the docks and was close to the pier-head and fruit market, so it is handy for many. It is a grand pub with six drinking rooms, including the smallest pub room in the country – with just three seats! The walls are decorated with interesting vintage photographs of the area, including the famous 'oss wash' – where cargos were transferred from cart to steamer, and horses were cleaned in the estuary water. In former days the pub came with its own brewery attached, the Minerva Brewery.

Our first record of The Minerva site is in sale documents now in the Hull Records Office (BRD 96) relating to the sale of 2,142 square yards, the sites of Nos 14–17 Pier Street, Nos 33–37 Wellington Street, Nos 3–8 Minerva Terrace and The Minerva Hotel to a William Westerdale of Sculcoates between 1813 and 1817. Westerdale was a mast, block and pump maker of No. 1 Pier Street with a shop at Old Dock West End. He died in 1837 aged sixty-six, and Thomas A. Wilkinson took over his business and No. 1 Pier Street. The Minerva Hotel originally occupied No. 5 Minerva Terrace by January 1829 and its first victualler had just retired from commanding the Hull–Hamburg steam packet, as the *Hull Rockingham* of 24 January 1829 attests:

Minerva Hotel – R. Cortis – thanks public for support after opening his house – beds are newly fitted up for their accommodation. Good fires will be kept, and attendance given on early tides, to suit all Steam Packets. He has also laid in a stock of superior old wines, spirits, etc. Trusting from every attention to their comfort he will insure their future favors. N. B. Post Chaises on the shortest notice.

Things soon started to pick up: the *Hull Advertiser* of 26 June 1829 tells us of a 'Meeting to be held at Minerva Hotel on 1st July to establish Regatta' – anyone with ideas for promoting aquatic amusements was invited to attend. By February 1831 The Minerva had expanded into No. 4 Minerva Terrace, as announced in this advert from the *Hull Packet* of 15 February 1831:

Minerva Hotel – R. Cortis – grateful for the many favours conferred on him by his friends and the public, begs leave to inform them that he has added the adjoining house to his establishment, and fitted it up with entire new beds, etc. His house being close to the landing

of all the steam packets, renders it very desirable, and commanding an extensive view of the Humber. The Gainsbro', Thorne, Goole, Selby, Barton, Grimsby, London, and Hambro' Packets use his house. Also the Scarbro' and Burlington coaches.

Richard Cortis, master mariner, was the owner of the Hull-registered ships *Elbe* and *Minna*. In July 1828, Cortis was commander of the steamship *London*, which had already made five voyages to Hamburg and was dispatched every fourteen days from Hull with goods and passengers. By 1846 he was manager for the Gainsborough Steam Packet Co. as well as managing the hotel. Richard's wife, Jane, died in 1834 aged forty-three, leaving ten children, two of whom were only six weeks old. By 1851 Cortis was a commission merchant and emigration agent in Wellington Street, living at No. 10 Nelson Street. By 1855 Cortis and Maples were seed and cake merchants, agents for the Nelson Assurance Company for baggage and sea passengers in Minerva Terrace.

When the steam packet *Gainsboro* exploded in the Humber Dock in 1837, killing seventeen men, one of the bodies had to be recovered from the roof of The Minerva.

The 1853 Ordnance Survey plan reveals that The Minerva has expanded along Nelson Street, with an extension to the front and a smaller house, The Minerva Tap, later Vaults, joined on. The Minerva Tap first appears in Freebody's 1851 directory. The North Eastern Railway (NER) had bought the hotel by 1899. Linsley's were the first company to tie the house after buying it from the NER. Linsley's were taken over by Duncan Gilmour & Co., of Sheffield, who were in turn taken over by Tetley's Brewery, the current owners.

There has been little change to the hotel externally since about 1850. Most customers drank in The Vaults rather than in the hotel and until recently only the bar in the hotel was used regularly. The Captain's room was damaged in the Blitz and not used again until the 1980s. The last recorded guest at the hotel was a Polish airman at the end of the Second World War (the register was stolen in 1980). Tetley's made an extensive internal restoration of The Minerva when the brewhouse was incorporated; it reopened in February 1985 – the fourth and only surviving brewpub opened by Tetley's. The brewery closed early in 1994 but reopened in July 1995, only to be permanently closed in 1999 to accommodate another bar.

The snuggest of snugs – room for one more, just.

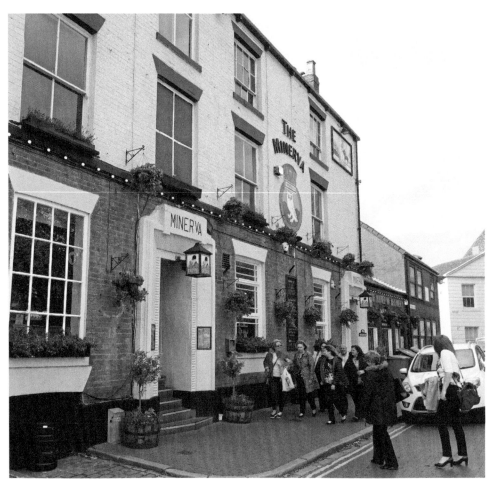

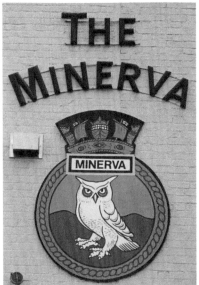

Above: Opening time for these hens.

Left: The pub's owl sign. The owl was the symbol of Minerva, the Roman goddess of wisdom, a quality in increasing supply in the pub as the evening wore on.

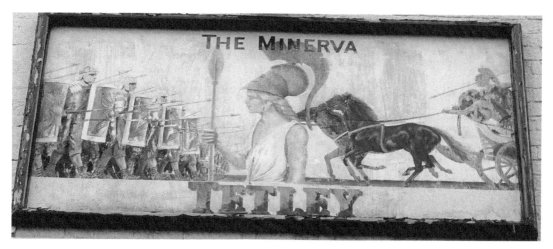

Above: Tetley's vivid depiction of Romans fighting Greeks.

Below: The beautiful green brickwork and tiling on the Humber Dock tavern.

A close-up of the tiling.

2. Humber Dock Bar & Grill, No. 9 Humber Dock Street, Hull

This pub was built before the construction of the dock opposite (now the Marina) in 1806 as The New Dock Tavern and then, in 1839, as The Humber Dock tavern. The name was changed again to *The Green Bricks* to reflect the famous green-glazed bricks of which it is partly built. These are not just green-fronted tiles but complete bricks. In March 2017 it was refurbished and renamed yet again to the Humber Dock Bar & Grill to reflect its nineteenth-century heritage.

3. The George Hotel, No. 1 Land of Green Ginger, Hull

The George Hotel was formerly the gatehouse or stable to a coaching house built in 1683, where visitors would be greeted and then shown to their rooms. It boasts the smallest pub window in England (a virtually invisible 10 inches tall by 1 inch wide), on the side of the coach entrance; from here the porter could see approaching coaches and customers – he would then rush out to welcome them and offer his services. In 1680 it was called Ye White Frere Hostel and The George Hotel Vaults in the early 1850s. The George was a thriving hostelry with forty bedrooms, restaurants and a billiards room. An auction room and traders' stockrooms completed the facilities.

The unusual street name recalls the days when Hull was a major international port, processing commodities from all over the globe. Or does it recall the herb garden that was once here? Another derivation has one G. J. Monson Fitzjohnson concocting a cocktail of green ginger, wine, honey, cloves and lemon juice for Henry VIII when the king came to stay in old Hull in 1540. Soon after, the street, then called Old Beverley Street, became known as Gingerland.

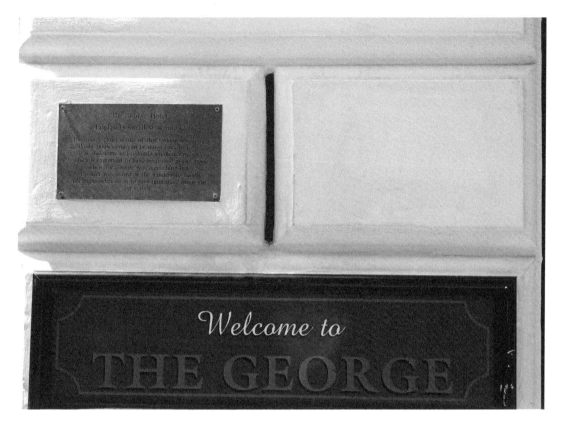

The tiny window – the vertical black line to the right of the plaque!

4. Ye Olde White Harte, No. 25 Silver Street, Hull

Probably the most famous of Hull's many famous pubs. The building was originally a private residence built in the Artisan Mannerist style – modest but with free use of Classical models, just like nearby Wilberforce House. In 1881 Smith & Brodrick made significant alterations begetting a Romantic recreation of an idealised seventeenth-century inn, complete with huge fireplaces.

Legend has it that in 1642 the English Civil War was hatched at Ye Olde White Harte, in an upstairs room. This room, aptly named the Plotting Room, has changed very little since the seventeenth century. The story goes that the pub was the residence of Sir John Hotham, one of Hull's military governors and keeper of one of the nation's largest arsenals, who in 1642 precipitated the siege of Hull, and in turn the Civil War, by refusing to admit Charles I to the city. But, sadly, this is nothing more than an urban myth: documentary evidence and architectural research in the late twentieth century tells us as much, proving that the building was not built until after the Civil War.

Research, however, has confirmed that Ye Old White Harte was the venue of the meeting to plot the overthrow of Lord Langdale, the Catholic governor appointed by James II, to seize all the town's Protestant officers, following the landing of William of Orange in England in November 1688. This major event was celebrated for many years as 'Town Taking Day'. The building became a pub in the 1730s and is now listed; the wood panelling and beautifully tiled inglenook fireplaces add to the unique sense of occasion for drinkers and diners.

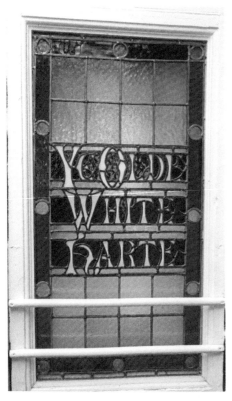

Left: One of the stained-glass windows.

Below: A fine fireplace for a fine pub in a fine city of culture.

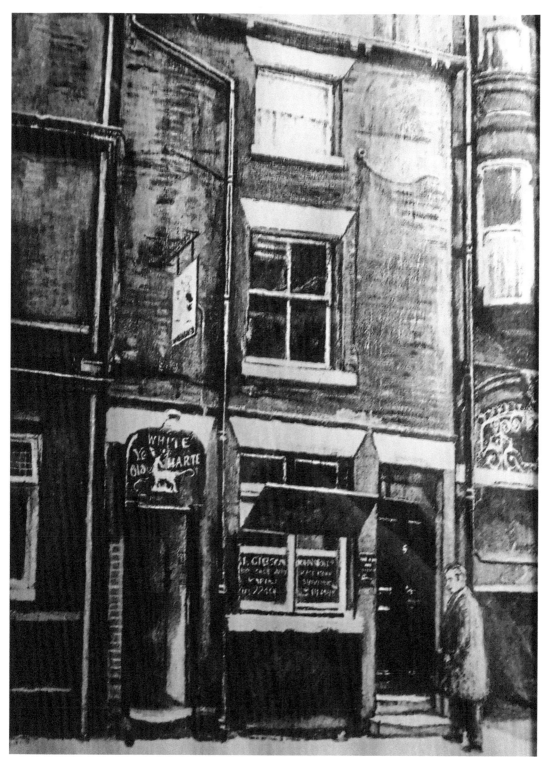

A drawing of Ye Olde White Harte in days of yore.

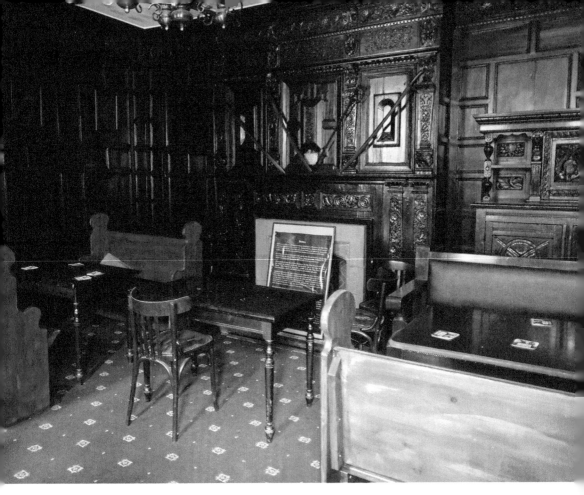

The fabled Plotters' Room.

The pub is also famous for its mysterious skull, which can be seen in a Perspex case behind the small Saloon Bar. Some say that the skull belonged to a young boy who died from a blow to the head, delivered by an angry sea captain full of French brandy. The boy's body was concealed under the staircase and remained undiscovered until a devastating fire in 1809. Others maintain that it was found in the attic, during the renovations of 1881, and is all that remains of a serving wench after an illicit liaison with the landlord, who was anxious to keep the affair quiet by placing the body in the attic and sealing it up. More likely – and less scandalously – it is a medical student's specimen skull.

The tragedies continued: twenty-six-year-old Fanny Clarkson, daughter of the landlord, John Clarkson, died when lighting the fire in the main bar in April 1806: the flames set fire to her clothing, resulting in fatal burns. In April 1912, staff turned up for work only to find the doors locked. The pub's cellar man, William Strutt, discovered thirty-eight-year-old landlady Clara Seapelt dead at the bottom of the stairs. She had collapsed at the top of the stairs before falling down and breaking her neck.

The year 1969 was a big one for the pub, and for the women of Hull. This was the year when ladies were permitted entry for the first time, but only if escorted and only in part of the downstairs bar. More recently, a pair of greenfinches have reared two chicks at the pub.

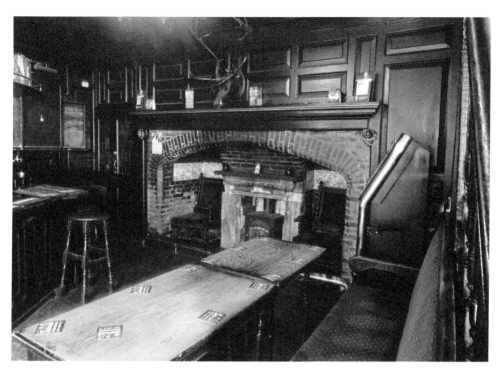

One of the best rooms in Hull.

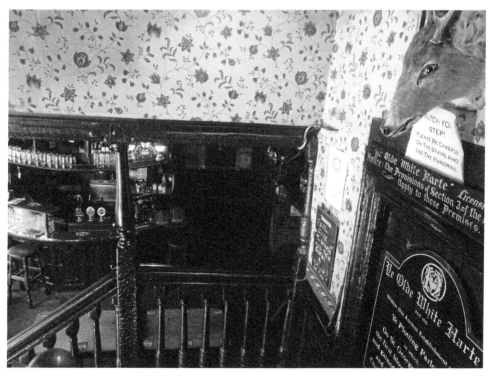

Looking down from the Plotters' Room.

5. The Lion and Key, No. 48 High Street, Hull

The site originally belonged to The Britannia Coffee House. The Lion and Key served its first ale in 1817, before it became offices in the mid-twentieth century. The 1980s saw it reopen as an Irish bar, Durty Nellys, before the current owners reinstated its original name in 2007. It is sister pub to Walters and Wm Hawkes nearby.

The name originated from Wellington's capture of Ciudad Rodrigo in 1812 during the Peninsular War. This town was considered to be the 'key' to Spain and the pub sign outside depicts a British lion with a large key in its paws. The inside is a sight to behold and the *Pubs Galore* website describes it well:

> The pub has been liberally decorated with all manner of items... The ceiling is covered with pump clips and suspended from it are a couple of large cartwheels acting as light fittings plus a big clock. High shelves are packed with various bits including lots of breweriana, old tankards, adverts, horseshoes and horse brasses, scales, bottles, first aid kits and the like. Meanwhile, the walls are almost entirely obscured by some great old adverts, posters, playbills and so forth.

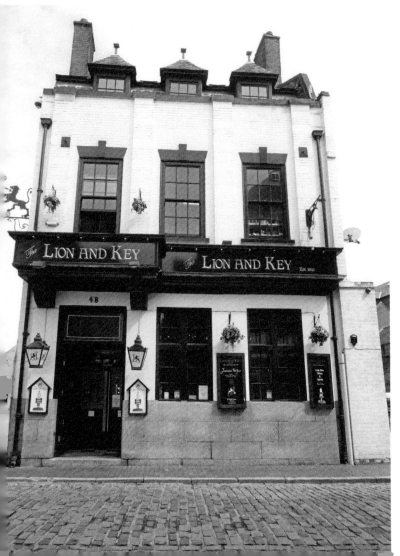

Left: The wonderful Lion and Key – we've got the Duke of Wellington to thank for this.

Opposite : We've got Durty Nelly to thanks for this.

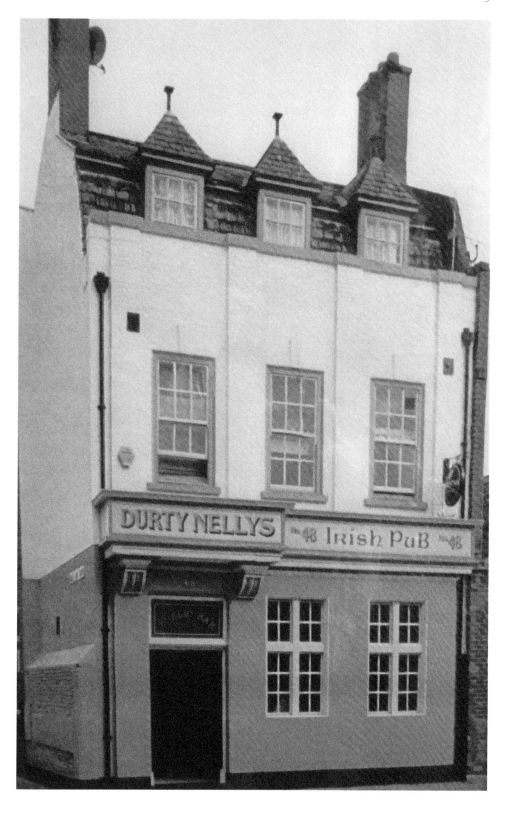

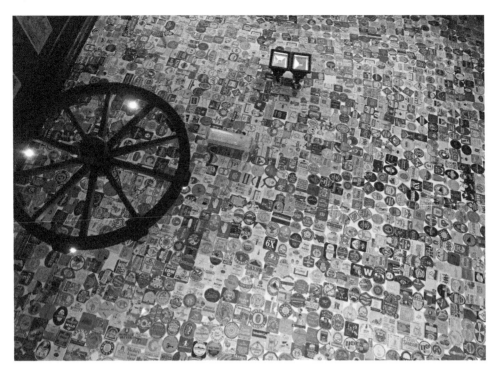

The view you get of the ceiling when you've fallen on your back.

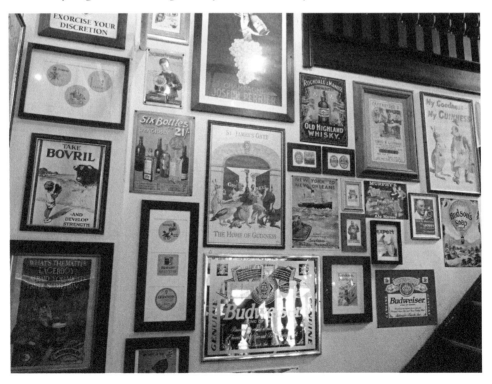

The superbly decorated walls.

6. The King William, No. 41 Market Place, Hull

This pub stands opposite the statue of William III in Market Place. It is reputedly where King Billy, having dismounted from his horse, went for a drink every night, as Holy Trinity tolled midnight. This is certainly a myth since the pub's drinks' license never extended so late. The 'King Billy', as it is known, started life as John Hellier's Coffee House and News Subscription Rooms. The building had formerly been a linen shop and then an ironmongers, before it was first licensed in 1834. In 1840 Henry Dean changed the name to Dean's Coffee House, running hot and cold vapour baths as a sideline. The year 1860 saw it take its regal name. The mortgage was transferred in 1887 to Gleadow, Dibb & Co., later the Hull Brewery Company Ltd, and later still Mansfield Brewery. The pub was refurbished in 2016 after some years languishing in dilapidation.

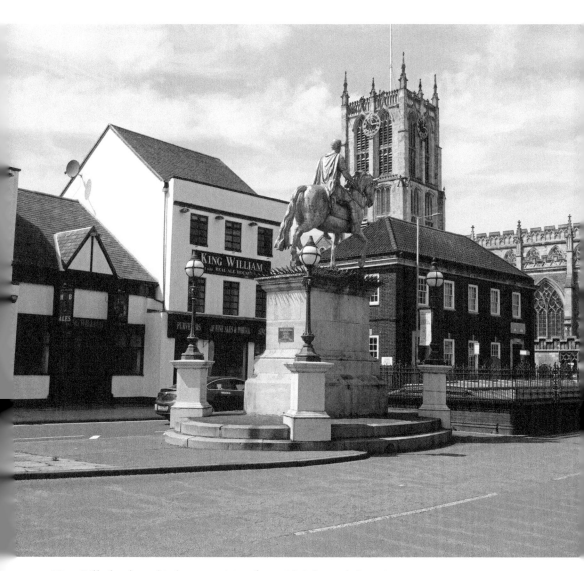

King Billy back on his horse waiting for midnight and that pint.

7. Ye Olde Corn Exchange, Nos 1–4 North Church Side, Hull

Situated next to Holy Trinity Church, in a building originally constructed in 1423, this pub is on the former site of the corn exchange, which took place here from the late seventeenth century. The Georgian building we see today was licensed in 1780 and there was a previous pub here called The Excise Coffee House from 1788 (and was possibly the same place as The Pig & Whistle). In 1820, William Soulsby renamed it Ye Olde Corn Exchange. From the late 1800s a wine and spirit merchant occupied the space; it was nicknamed Percy's Place after a landlord who was also chairman of Hull Kingston Rovers. This closed in 1913. Underground passages lead to the River Hull.

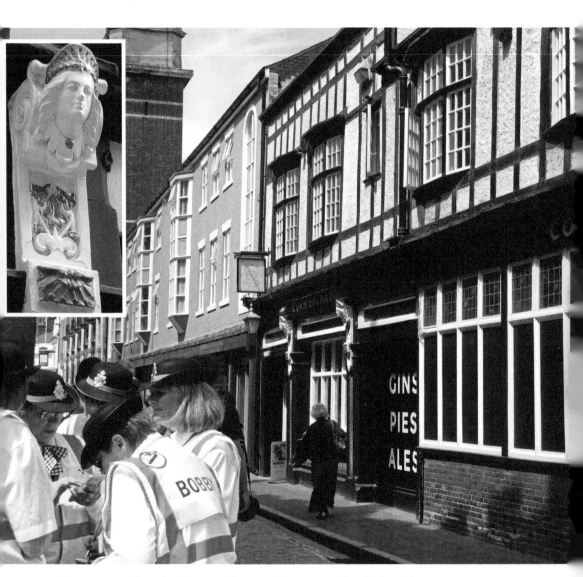

Planning a raid on the Corn Exchange? They were all called Bobby.

Inset: One of the pub's fine carvings.

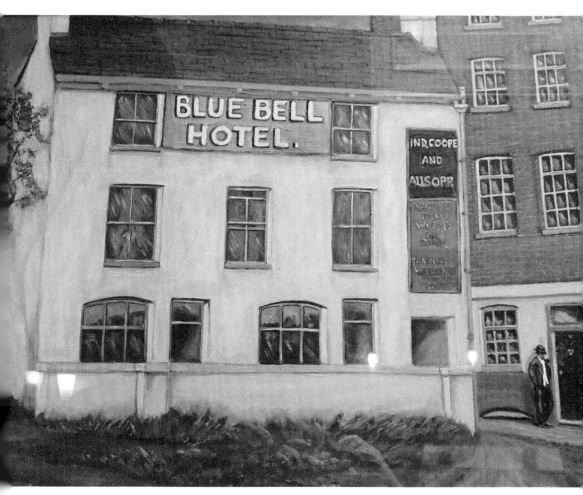

The Blue Bell painting in The Blue Bell.

8. The Blue Bell, Nos 54–56 Market Place, Hull

This pub can be found in an inconspicuous alley off Lowgate, flagged by a large blue bell that is the inn's sign. It is quintessentially Victorian but has been around since the 1790s, when it was an oasis for market workers. The Blue Bell was originally a coaching inn, seeing coaches arrive from and leaving for Patrington, for example. During the Blitz landlord Martin Cross valiantly saved his burning pub from incineration. His parrot, Polly, was partial to many a gin and tonic over her twenty-five years in residence. The pub was refurbished by Cameron's Brewery of West Hartlepool in 1965 and then by its present owners, Tadcaster brewers Samuel Smith's, in 1986.

9. The Wm Hawkes, No. 32 Scale Lane, Hull

The eponymous William Hawkes was a gunmaker and dentist (not at the same time) and manufactured guns and rifles in the building from 1810 (or maybe 1750) having taken over from a previous gunsmith called Bottomley. Lest we forget the pub's heritage, the main room is replete with artefacts and mementos (firearms, not teeth). From the outside the

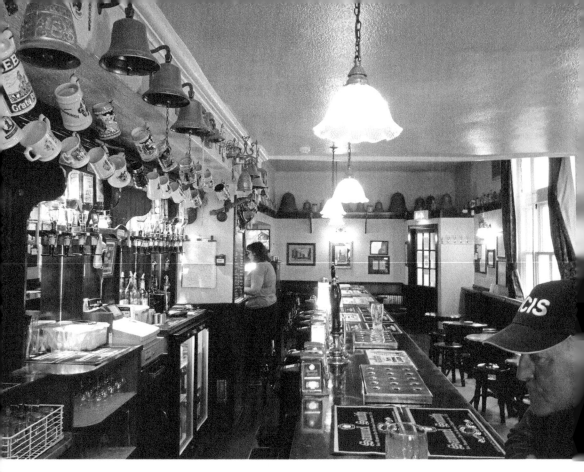

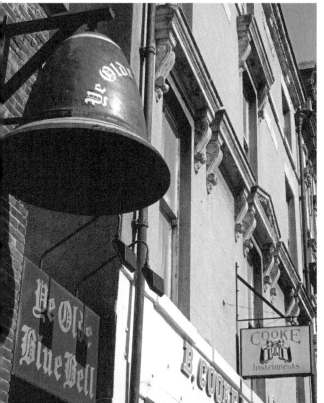

Above: Inside The Blue Bell – note all the bells.

Left: The big blue bell at The Blue Bell.

inconspicuous Wm Hawkes façade could pass as a Dickensian film set, and inside the rooms are atmospherically candle-lit. Until recently, Wm Hawkes was a printer's workshop – this is the first time it has been a pub in its 600 or so years.

The pub (sister to The Lion and Key and Walters) is unusual because you will find no lager on draft, nor any bottled here. The rationale underpinning this radical policy is that there are enough British ales that adequately do the job of refreshing just as well as lager – so why waste money profiting German, Dutch, Danish and Czech companies?

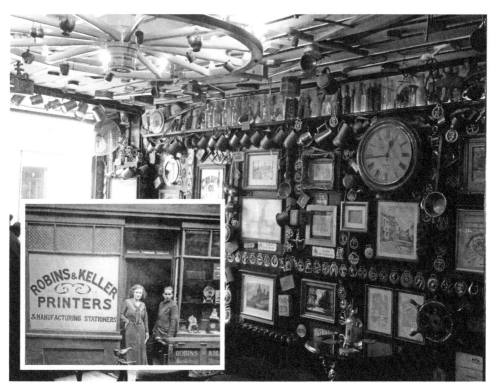

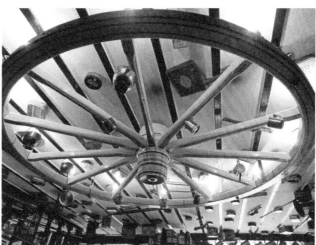

Above: The fabulous inside.

Above inset: In the printing days.

Right: Ship's wheel on the ceiling.

10. Walters, No. 21 Scale Lane, Hull

This pub takes its name from barber Walter Wilberforce, who owned and ran the premises in the 1820s.

11. The Manchester Arms, No. 7 Scale Lane, Hull

Established in 1791, earlier days have seen this public house glory in such evocative names as The Blade Bone, The Slaw Bone, The Earl Grey and The Black Bull Inn before becoming the The Manchester Arms in 1876. It is named after HMS *Manchester*, which was the first ship to enter Hull's first ever dock. Next door stands Hull's oldest building. There are black and white stone-carved cherubs on its façade and etched windows and carvings of two drinkers, mouths agape, drinking from barrels, and a lion's head. Inside, the ceiling is red, blue and green. The back room displays a large map of Hull annotated with accounts of its history. A ship's wheel hangs on another wall.

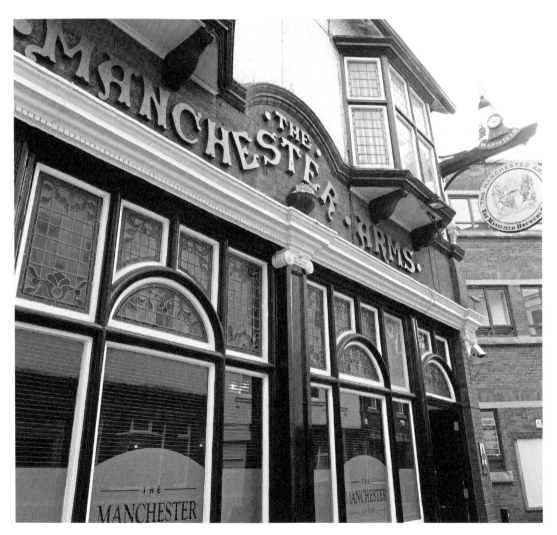

The Manchster Arms.

12. The Manchester Hotel, George Street, Hull

This hostelry was named after proprietor Ratcliffe Manchester in 1887. The former name was The Salisbury Hotel, after the third Marquis of Salisbury (1830–1903) and Prime Minister of Great Britain on three occasions. When William Frederick Cody (Buffalo Bill) came to Hull to perform his Wild West Show in May 1888 at Boothferry Park, his plan was to stay at The Royal Station Hotel. This great man, who was part of the anti-slavery campaign, rode with the Pony Express, served in the Union army and fought in the Indian wars, was deemed undesirable and refused entry; however, Ratcliffe Manchester saved the day and took him in.

13. Ye Olde Black Boy, No. 150 High Street, Hull

This is the oldest pub in Hull, dating back to around 1720. The premises were originally used by a tobacco merchant who traded from the River Hull; the intriguing name reputedly comes from the 'black boy' – the pipe-smoking American Indian which was adopted as a symbol by the tobacco trade.

The pub is alleged to have been frequented by slavery abolitionist and champion of the partially sighted William Wilberforce. The building was later occupied by a wine merchant.

The site was known as Gastryk House. In 1336, Richard Taverner took over a tenement, a gift of William de Gastryk to Richard's father, Hugh. The first reference to licensed premises here is in 1729, when victualler William Smith and his wife Mary bought a garden at the rear of their house (No. 149 High Street) from a baker and erected a brewhouse on the

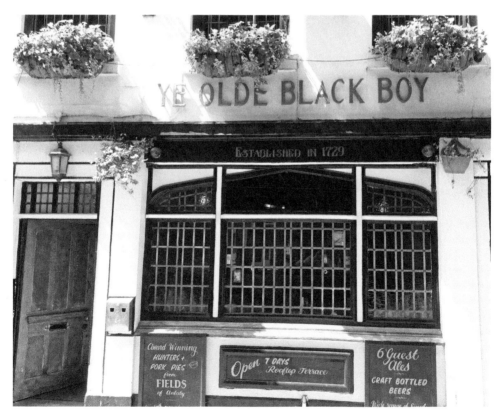

Ye Olde Black Boy.

The atmospheric gaslit main
bar.

The wonderful window in
the front bar.

Back bar, again with
paraphernalia and posters.

site. The first record of the name of the pub is in 1748, when a deed involving William Hayton, baker, mentions Ye Olde Black Boy. Another deed dated 3 March 1879 describes the property as '150 High Street and also two cottages adjoining in rear of 149 High Street, formerly called the Black Boy'. The first trade directory reference to Ye Olde Black Boy as a licensed premises is in 1792, when James Hayes was the victualler. A year later an auction was held at Ye Olde Black Boy to sell a brewer's dray. A brewer bought the pub in June 1808: 'Lupton, Holden & Dewitt offer for sale the Black Boy, High Street, together with the tenement, pipemakers shop and premises adjoining.'

Lupton & Holden were brewers at No. 56 High Street and James Dewitt was a ship owner and wine merchant in North End from 1810 to 1811. By 1842 the Black Boy was advertised as a free house, having passed from the brewers to a wine and spirit merchant. A promotional flyer printed for Warwick & Co. (Hull) Ltd, owners between 1923 and 1925, describes the premises:

> This house in bygone days was a regular meeting house for merchants and others. Messrs. Warwick & Ward (Hull) Ltd., wish to intimate to those concerned, that facilities for meeting there still exist. The bar downstairs retains its old characteristics, and one can sit there at ease in cheerful comfort surrounded by highly polished hogsheads and glistening bottles. Two rooms upstairs are available for small business meetings. The rooms are fully equipped for these purposes, and whilst they are part of the old inn, they have a separate entrance, and it is not necessary to pass through the bar to gain admittance to them. Situated in the heart of Hull's business community, they form an ideal place of meeting. Anyone desirous of arranging small meetings is invited to make application to the Manager for the use of these rooms. Liquid refreshments can be served in them during licensed hours.

In 1968, when Kenneth and Patricia Atkinson were licensees, a fire in a derelict smithy spread to the back of Ye Olde Black Boy. The pub's dog, aptly named Sooty, raised the alarm and so prevented serious damage. In 2015 the façade of Ye Olde Black Boy was painted bright pink to mark the Freedom Festival. The aim was to send out a message that colour matters not.

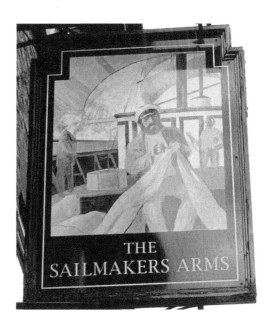

Who needs the words when signs are this descriptive?

14. The Sailmakers Arms, Chandlers Court, No. 159 High Street, Hull

Not to be confused with a solicitor's office, with whom the pub shares its entrance. The name comes from the fact that there have been ships' chandlers here since 1850. In 1988, a local solicitor converted the last chandlers into the pub we see today. The function room is in the sail loft.

15. The Head of Steam, No. 10 King Street, Hull

Opened on 14 July 2016, *The Head of Steam* is owned by that wonderful brewery and makers of Strongarm ale, Camerons of Hartlepool. It was previously named The Purple Pig and The King's Ale House.

16. The Bonny Boat, No. 17 Trinity House Lane, Hull

This pub was trading from 1791 from this site when Trinity House Lane was called old Beverley Street. Before then it was The Bank Hotel. It is awash with nautical nostalgia: three barometers; a sign saying 'Port hole to be closed when ship is at sea', and a big bell from the tug *Brahman*, famous for rescuing a Royal Navy ship struck by a torpedo in the Second World War. Outside there is some glorious green-glazed tiling.

The name remembers an old Inuit kayak still owned by nearby Trinity House. Captain Andrew Barker from Hull was in command of a ship called the *Heartsease* on an early seventeenth-century expedition to Greenland in search of minerals when they found an kayak with an exhausted Inuit. The poor man sadly died, but he is remembered by his kayak and a likeness of himself, and the nearby pub. The kayak was brought from Spitsbergen to Hull in 1596.

The wonderful story is recorded in *Through England on a Side Saddle in the Time of William and Mary* by the enterprising and fearless Celia Fiennes when she called in at Hull during her journey through every county in England. Her diary gives us a fascinating account of her travels and an insight into late seventeenth-century life:

1697 Tour: Hull to Chatsworth
We enter ye town of Hull from ye Southward over two drawbridges and gates, there is the Same Entrance in another part of ye town by 2 gates and 2 drawbridges from Holderness, and so ye ditches are round ye town to ye Landward, and they Can by them floate ye grounds for 3 mile round wch is a good ffortification. The Garrison and plattforme wch is the ffortification to ye Sea is in a very uniforme ffigure and were it ffinished is thought it would be the ffinest ffortification that Could be seen-its wall'd and pallisadoed. I walked round it, and viewed it and when I was on ye water, it seemes to runn a great Length and would require many Soldiers to deffend ye halfe moons and workes. In the town there is an hospitall yts Called ye Trinity house, for Seamens widdows, 30 is their Completmt, their allowance 16d pr weeke and ffewell, they have a little Chapple to it for prayers; over this building is a large roome for Cordage and sailes, where they make them and keep their Stores. In the middle of this roome there hangs a Canoe to ye Roofe of ye Roome just bigg Enough for one man to sit in, and the Effigie of a man that was taken wth it, all his Cloths Cap and a Large bag behind him where in his ffish and provision were, these were all made of ye skin of ffishes and were ye same wch he wore when taken, ye forme of his face is only added and just resemble ye wild man that they took, for so the Inscription Calls him, or ye bonny boate man; he was taken by Captn Baker and there are his oars and spear yt was with him – this is all written on ye boat to perpetuate ye memory of it; he would not speak any Language or word to them yt took him nor would he Eate, so in a few dayes died.

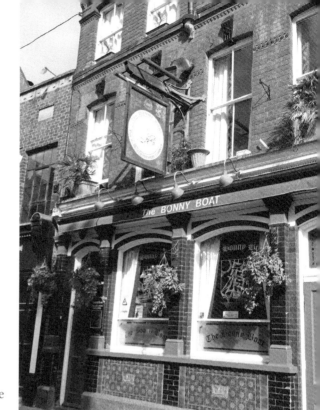

Right: Outside The Bonny Boat, with tiling.

Below: Inside The Bonny Boat with the bar reflected in the mirror.

The Bonny Boat bar.

The Bonny Boat maritime paraphernalia.

Landlord Tom Jackson closed the pub at the end of the nineteenth century because the brewery refused to build a ladies' toilet. Hull's Trinity House naval school across the road refused to admit women until 1993, when Lisa Hannan was the first female student there.

17. The Kingston Hotel, No. 25 Trinity House Lane, Hull

This is an impressive corner building opposite Holy Trinity Church and boasting a lot of glass, including a spectacular curved window. Other features include a fine Victorian bar back – mirrored black and red – made out of parts of an old ship, and six ornamental alabaster prow heads situated around the building, also from old ships. There is a small room to the rear of the bar.

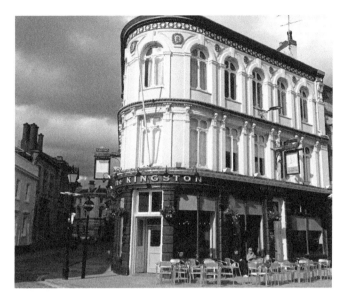

The Kingston Hotel
today.

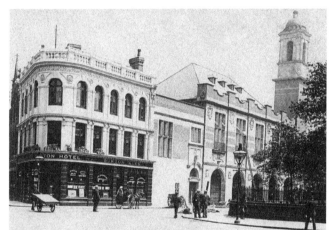

The Kingston Hotel in
the 1950s.

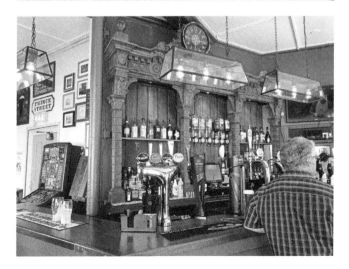

The impressive back bar
at The Kingston Hotel.

18. The Mission, Nos 11–13 Posterngate, Hull

This atmospheric pub is noted for its spire, fine stained-glass window in the west wall and wooden pews. Formerly the chapel for a Seaman's Mission founded in 1926 it was, until recently, used as an overflow service called 'full mission' from nearby Holy Trinity Church. The Seamen's Mission was built in 1886 and was a kind of club and hostel for sailors situated just opposite the offices of the Local Marine Board, where sailors would have to sign on and get paid off when going to sea. It was extended in 1926–27 to form the Mariners' Church of the Good Shepherd Owners. The Old Mill Brewery in Snaith was established in 1983 and opened The Mission in 1995.

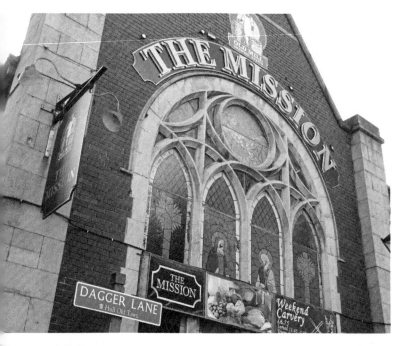

This must be one of the most spectacular pub gable ends in England.

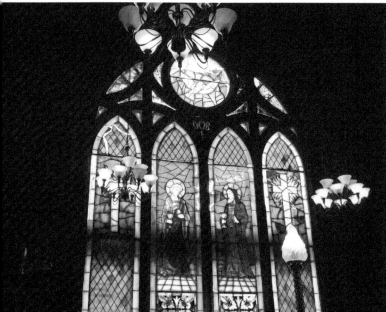

One of the stunning stained-glass windows.

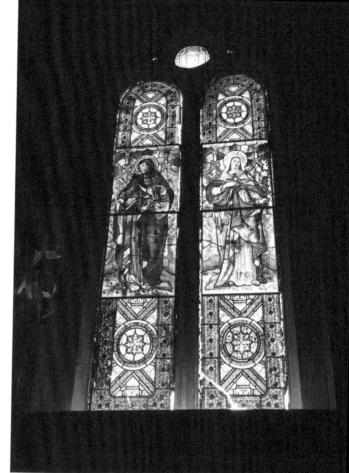

Right: Another glorious window. After six pints here you think you've died and gone to Heaven.

Below: Atmosphere is available on tap here.

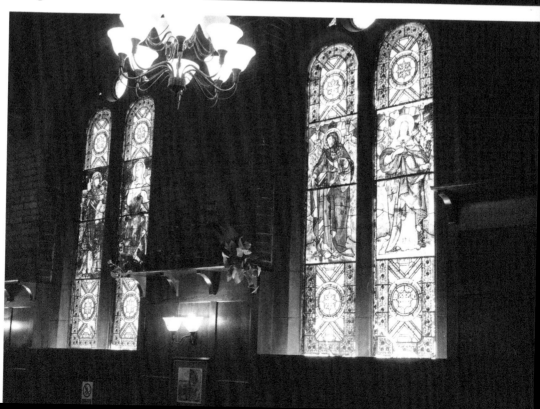

In 2011, for the first time in Holy Trinity's 700-year history, the church held an informal monthly worship at The Mission pub. The monthly services are called 'full' from the Gospel of John, where Jesus says he has come so that people would have 'life and have it to the full'.

19. The City Hotel, Alfred Gelder Street, Hull

Pubs on this site date back to 1840, when the first was called The City of London Arms, or just The City Arms. It later became The Town Hall Vaults (in the 1860s), and The Tiger No.2 (in the 1870s). Demolished, it was rebuilt in 1905 by Hewitt Brothers, brewers of Grimsby, as The City Hotel. It proudly displays the three crowns, insignia of the City of Hull. When John Stephenson (or possibly George Stevenson, landlord of The Tiger in Waterworks Street) bought six inns, he named them all The Tiger and a respective number; however, the pubs soon reverted back to their original names. Here are the six Tigers:

The Tiger, Waterworks Street = The Tiger No.1
The Town Hall Vaults, Alfred Gelder Street = The Tiger No.2
27 Church Street, Sculcoates = The Tiger No.3
The Golden Cup, Mytongate = The Tiger No.4
The Ferry Boat, Wincolmlee = The Tiger No.5
The Labour in Vain, Humber Street = The Tiger No.6

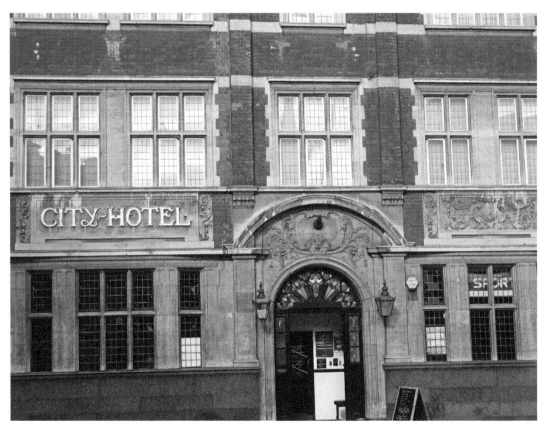

The City Hotel.

20. The White Hart Hotel, Alfred Gelder Street, Hull

Hart is an archaic word for stag, the emblem of Richard II who inherited it from the arms of his mother, Joan, 'The Fair Maid of Kent'. It could also be a pun on his name – 'Rich-hart'. The Wilton Diptych in the National Gallery, London, shows Richard II (the earliest authentic contemporary portrait of an English king) wearing a gold and enamelled white hart jewel, while the angels flitting around the Virgin Mary all wear white hart badges.

The hotel is on the site of a pre-1826 White Hart; it was rebuilt in gin-palace style in 1904, boasting a wonderful mock-Tudor façade while inside there is a fine early Edwardian mahogany-topped semi circular ceramic bar with green and gold tile work. Paraphernalia includes an ancient carpet cleaner. Philip Larkin drank here and in 1977 he gave a talk to the Jazz Record Society entitled 'My Life and Death as a Record Reviewer'. The White Hart is the fifth most popular pub name in Britain.

21. The Three John Scotts, City Exchange, Alfred Gelder Street, Hull

This pub is named after three successive vicars of nearby St Mary's Church, all of them called John Scott – grandfather, father and son. It is on an ancient site, where Suffolk Palace was – the home of the wealthy local merchants' family, the De la Poles, until it was appropriated by Henry VII, who bequeathed it to his son, Henry VIII, who stayed here. Nearby Bowlalley Lane is so-named because Henry allegedly played bowls in Suffolk Place. In 2016 the Channel 4 series *National Treasure* starring Robbie Coltrane, Julie Walters and Andrea Riseborough was filmed here, with the pub posing as the Old Bailey. Today it is a JD Wetherspoon pub.

22. The Burlington Tavern, No. 11a Manor Street/Alfred Gelder Street, Hull

This is a restored Georgian corner pub known as The Bridlington Tavern in 1770, then The Witnesses Arms and Convict Arms until 1826, due its proximity to the Magistrates' Court in the Guildhall across the road. Prisoners allegedly had their last drink here before sentencing. It is the only surviving pub in the old town with the toilets upstairs. The pub sign shows George Augustus Cavendish, 1st Earl of Burlington, looking down on us, with 'Maritime Prowess' – the statue of the Greek goddess Aphrodite rising from the waves between two horses – on the Guildhall roof behind. Note: Bridlington used to be called Burlington.

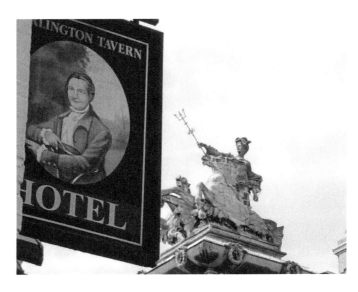

The Burlington Tavern.

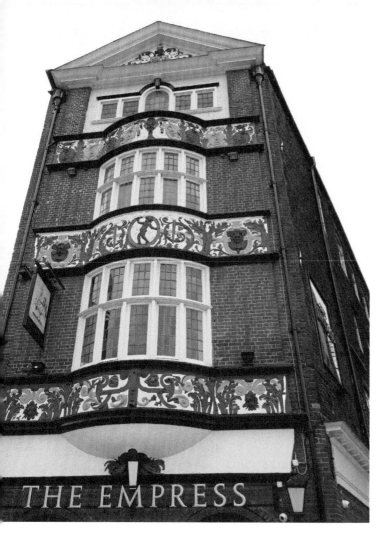

The Empress.

23. The Empress, No. 20 Alfred Gelder Street, Hull

The Empress is a fine-looking former Queen's dockside pub looking out onto Queen's Gardens; it was originally called The Dockside Tavern in 1790, or just plain Dock, and then The Old Dock Tavern, refreshing those working on the nearby Queens Dock. Toilets were in the building next door. The building was originally a dockside warehouse. We have a German landlord to thank for the name change in 1876: Herr Westeroff, obviously keen to cement national ties with the monarch, successfully applied to change the name to The Empress (of India) with the proviso that the pub remained closed on Sundays.

24. The Punch Hotel, Queen Victoria Square, Hull

This extremely ornate Victorian building is not the original. The first Punch was built in 1845 facing Waterhouse Lane at the rear of the present Punch Hotel in Queen Victoria Square, some of which is now under the entrance to the Princes Quay shopping complex. The redevelopment of St John Street and Waterworks Street in 1894–95 saw the old Punch demolished and rebuilt by the Hull Brewery Company in the new Square; the elaborate façade of terracotta and magnificent Burmantoft's faience was designed by Smith, Broderick and Lowther. The Grade II-listed building is regarded by many as an architectural masterpiece.

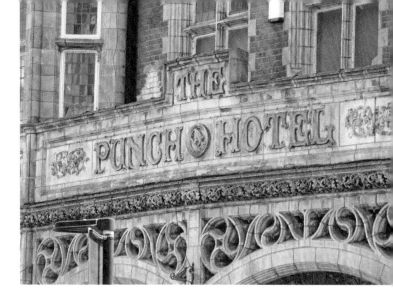

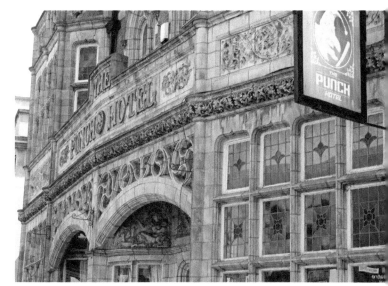

Two shots of the façade with its terracotta and magnificent Burmantoft's faience.

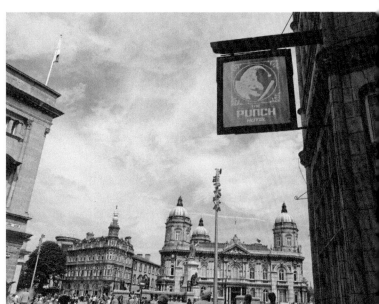

Pub sign with the maritime museum in the distance.

25. The Rugby, No. 5 Dock Street, Hull

Its original name was The Ship Molly in 1820, when it was situated at the Queens Dock. The *Molly* was a 1759 New England vessel which became part of Hull's whaling fleet from 1775 to 1806, when it was captured by the French. One *Molly* captain was the prodigious whale-catcher Angus Sadler, who, when commanding *The Aurora*, brought home no fewer than forty-four whales from one trip in 1804. When John Townend became landlord in 1900 he changed the name to The Rugby – Townend had been captain of Hull FC. The Rugby was rebuilt in 1986.

26. The Hull Cheese, Nos 39–41 Paragon Street, Hull

There has been an inn on this site since the late eighteenth century. The Hull Cheese had something of an unsavoury reputation in the nineteenth century. Formerly known as The Paragon Commercial or The Paragon, it was here that Maria Moody, a 'dangerous' and 'violent woman', assaulted George Ringer with a broken glass before attacking the arresting officer, PC Pearcy, in November 1889. In June 1890, Henry Emsley Midgley was attacked in the billiard room by Louis Hickman.

In 1800 it had stabling, and in the 1950s and '60s it was home to the infamous Red Room – a knocking shop by any other name.

The pub's odd name is a reference to the strong, thick beer brewed in Hull and exported from Burton through the port of Hull. According to bargee John Taylor (1578–1653), the self-styled 'Water Poet', '[Hull Cheese] is much like a loafe out of a brewer's basket; it is composed of two simples—mault and water ... and is cousin-germane to the mightiest ale in England'. He further wrote:

> Thanks to my loving host and hostess Pease
> There are at mine each night I took my ease,
> And there I got a canticle of Hull Cheese.

The phrase 'you have taken Hull Cheese' means that you are well and truly drunk. Similar expressions include 'he hath been bit by the barn-weasle'.

27. The Royal Hotel Hull, No. 170 Ferensway, Hull

The Royal Hotel Hull is described in Philip Larkin's Friday Night at the Royal Station Hotel as a place where 'silence laid like carpet'. Other Larkin haunts include The George Hotel, Ye Olde Black Boy, The White Hart and The Goodfellowship Inn on Cottingham Road.

G. T. Andrews designed Hull's Paragon Station and the adjoining *Station Hotel*; they opened in 1847 as the new Hull terminus for the burgeoning traffic of the York and North Midland Railway (Y&NMR) leased to the Hull and Selby Railway (H&S). The station and hotel were built in the Italian Renaissance style, with both Doric and Ionic columns; the façades owe much to the interior courtyard of the Palazzo Farnese in Rome. Sadly, much was destroyed in a devastating fire in 1990. Queen Victoria came to stay at the hotel in October 1853; a throne room was created on the first floor, with the royal household – including the Queen, Prince Albert and five royal children – accommodated on the second. The visit concluded with a dinner at the hotel on 14 October. Privatisation of British Transport Hotels in the 1980s saw *The Royal Station Hotel* renamed The Royal Hotel Hull.

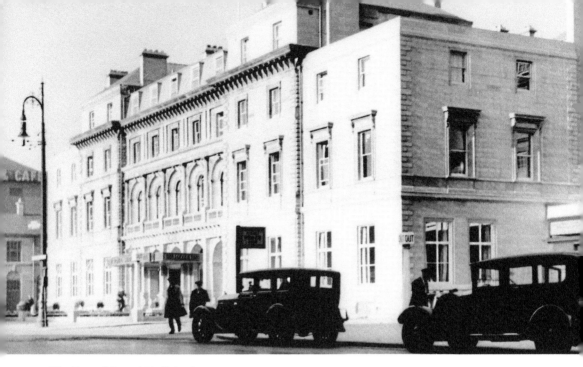

The Royal Hotel Hull in the 1930s.

28. The Vauxhall Tavern, No. 1 Hessle Road, Hull

This is one of Hull's last remaining pubs with Regency features and bow windows still intact. This pub was licensed in 1810 and is now the oldest in Hessle Road; it was once known as Paddison's Spirit Vaults and Frankie's Vauxhall Tavern.

29. The Hop & Vine, No. 24 Albion Street, Hull

Hull's smallest real ale and cider pub. A former wine bar called The Vine, it is a bijoux single-roomed cellar bar in the basement of the only remaining Georgian terrace in Hull city centre. Grade II listed, the pub champions an interesting relationship between brewing and bread-making. Up to five different breads are freshly baked everyday and are used in the sandwiches and paninis.

30. The Old English Gentleman, Mason Street, Hull

Near to The New Theatre (once Hull's Assembly Rooms), The site of the Old English Gentleman dates back to the early nineteenth century, when it was a flower shop and part of a Georgian terrace. Around 1832 it was owned by Edmund Halley, a chair-maker, shopkeeper, flour dealer and hackney gig owner. The pub boasts an impressive collection of over 100 photos of some of the actors who have either trod the boards at nearby theatres or had a drink here. There is a shrine to Laurel and Hardy who came here in 1947, with pictures and a couple of bowler hats on display.

31. The Albion, Nos 19–20 Caroline Street, Hull

The Albion has recently undergone a radical interior and exterior renovation. The striking pink façade will be complemented by rainbow colours. The George in Walton Street, west Hull, is similarly renovated to come out as The Gay George.

32. The Whalebone, No. 163 Wincolmlee, Hull

Built sometime around 1800, the Whalebone is probably the city's last remaining example of a true docker's pub; it has traditionally been frequented by them and most of the current clientele seem to be former fishermen. The pub makes no excuses, takes no prisoners and stands as a monument to the drinking culture of the average working men of the city...if you like art deco windows, no-nonsense banter, living history and very cheap beer you should seek The Whalebone out and find out what Hull is made of. (https://davelee1968.wordpress.com/2010/05/29/pub-of-the-week-the-whalebone-hull/)

By far the best, the definitive history of *The Whalebone* is by Paul Gibson, from which this account is adapted.

The site of The Whalebone pub is on an ancient route from Hull and Drypool to the old village of Sculcoates, known as Wincolmlee today, an area of kitchen- and pleasure-gardens in the 1820s and '30s. The Ordnance Survey in 1852 shows ten properties between Green Lane junction and the entrance to Pot House Yard; the 1881 Census reveals that these properties were home to thirty-eight people in eight of the houses, which included The Whalebone and two shops. There was a brewery and maltings opposite The Whalebone, originally occupied by brewer and maltster Joseph Lockwood from 1776. In 1794 John Rivis took over the brewery, located at 65 Church Street. In 1819 Rivis let The Sculcoates Tavern on the corner of Scott Street and Wincolmlee; confusingly, The Sculcoates Tavern had previously also been known as The Whale's Shoulder. The Sculcoates Tavern was using this name by 1803, but the first known reference to The Whalebone in Church Street was in 1814, but not by name until 1822. There were at least three Sculcoates Taverns hereabouts at one point. Clearly, the present Whalebone is not the original structure; a 1926 plan shows that the rebuilt 1880s' Whalebone underwent more alterations throughout the twentieth century.

Paul Gibson explains the origin of the name:

One early recorded name for the Whalebone was the Splaw Bone, which is part of a Whale's shoulder, the name was a reference to the many Greenland Yards in the area; Whaling ships sailed from these yards and many were built along the banks of the river Hull. The peak of Hull's whaling imports coincided with the first mention of the Splaw Bone pub in the trade directories; in 1815, at least 57 whaling vessels discharged their cargo in Hull, a figure equalled only once … The pub's sign (not always a painted picture as we expect today) was a large bone hung from a pole or beam… The early recording of the pub name as the Sloop may suggest that the picture of a ship, possibly a Hull Sloop, or that the whaling ship the Manchester … was carved on the bone. This is not unusual as scrimshaw work like this was common in Hull.

33. The Bay Horse, Nos 115–117 Wincolmlee, Hull

The Bay Horse was a community local with separate bar and lounge which extend into a former blacksmith's shop. Built in 1803, The Bay Horse has a lurid past: in February 1927 the landlord, forty-three-year-old John William Boothby, was found by his mother with his throat cut. She was alerted by blood dripping through the ceiling down into the bar. She ran to alert a neighbour, John Atkin, who rushed upstairs and found Mr Boothby in bed with his throat cut. The inquest returned a verdict of 'death by suicide'.

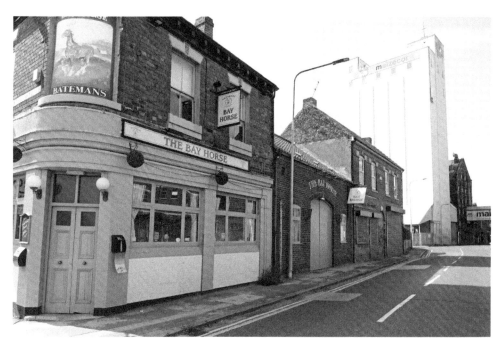

Above: The Bay Horse.

Right: The Bay Horse's superb sign.

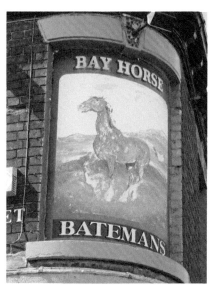

34. Plimsoll's Ship Hotel, No. 103 Witham, Hull

Known as *The Ship* from 1815, the façade was renewed in 1874 and with it came the new name. There was stabling for twenty horses, illustrating its role as a coaching inn. Samuel Plimsoll hit on the idea of the lifesaving line which bears his name when he saw the so-called 'coffin ships' off the coast – battered old tubs which were often dangerously overloaded and frequently sank as a consequence. The Plimsoll Line (a reference mark located on a ship's hull that indicates the maximum depth to which the vessel may be

safely immersed when loaded with cargo) became a legal requirement under the Merchant Shipping Act of 1876. Samuel Plimsoll married Harriet Frankish Wade in 1885, daughter of a Hull timber merchant. Dilapidated in 1985, the pub was rebuilt in 1987 with its impressive interior dome.

35. The Polar Bear, No. 229 Spring Bank, Hull

A pub since the mid-1800s, The Polar Bear (like The Botanic next door) gets its name from the old Hull Zoological Gardens, a long-gone Victorian attraction on the opposite corner of Spring Bank and Princes Avenue which opened in October 1840. The polar bear pit was a popular feature.

The Polar Bear is one of only eleven pubs nationwide that still serves from a ceramic bar. According to the *Yorkshire Post*, it is 'a wonderfully impressive, huge, curved affair that is now Grade II listed along with the pub's equally attractive stained glass dome ceiling. Coincidentally, one of the other ceramic bars is also in Hull, in the White Hart on Alfred Gelder Street' (29 September 2013).

The second licensee of The Polar Bear, from around 1850 until at least 1867, was Joseph Seaman. Mr Seaman was a man of many talents: as well as being victualler of The Polar Bear *Tavern*, he was superintendent of the Zoological Gardens, chief scenic artist and 'pyrotechnist' at the gardens, model maker and taxidermist. Many of the animals in the Zoological Gardens were brought to Hull by sea and as the in-transit mortality rate of the various species would have been high, Mr Seaman had a ready supply of specimens for his taxidermy.

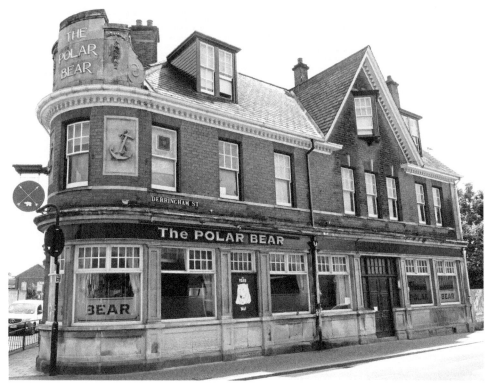

The Polar Bear with fine windows and Hull Brewery anchor.

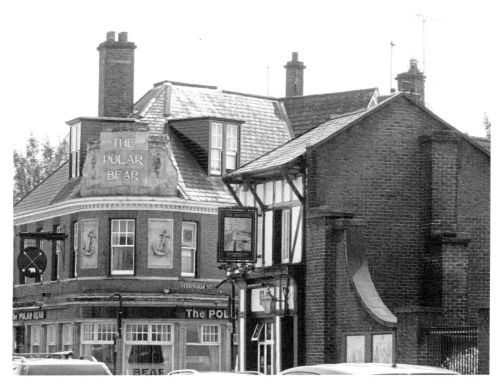

The Polar Bear again, this time with timbered botanic next door.

In March 1848, the *Hull Advertiser* ran an advertisement which reveals that the pub had a popular shooting gallery and was to be let by the unfortunately named spirit merchants Messrs Acrid & Son and Thomas Greasley:

> To Be Let, with immediate possession, all that public house, with outbuildings, and well-frequented Shooting Gallery attached, situated opposite the Zoological Gardens, Spring Bank. Incoming for fixtures, Furniture &c, about £200. Apply to Messrs Acrid & Son, spirit merchants, Robinson Row; or to Thomas Greasley, Auctioneer, Hull.

A further advertisement in 1854 tells us about the museum run by Mr Seaman, which featured an ostrich, a pair of lions and a 15-foot elephant called Tom – all very exotic in those days. By July 1861 a terrace of three houses was built on the site of the old Polar Bear *Inn*, which was presumably bought and demolished. The three houses are still there and form Nos 117, 119 and 121 Spring Bank – adjoining the west side of the present *Hole in the Wall* pub, which is No. 115. However, by 1860 houses and a shop were built at the corner of Derringham Street and Spring Bank – the shop was the new Polar Bear Tavern, listed in a trade directory of 1863–64 as The Museum. It was a basic beerhouse with only one room for customers, marked simply as 'shop', with the main entrance on Spring Bank. In 1861 a purpose-built museum was built adjoining the new Polar Bear for Mr Seaman, but it was destroyed by fire in 1865. Mrs Gleadow, who lived next door, was the widow of the late Robert Ward Gleadow who died in 1857; together they had run the Gleadow, Dibb & Co. Brewery, later the Hull Brewery Company Ltd from 1887.

By 1895, the shop became a 'dram shop', the sitting room became a 'Smoke Room', new toilets were added, and a carriage house and stables were built in Derringham Street. Typically for the time, it was fitted out with an 'orchestra' area for small recitals. The impressive dome and top-light were added at this time, as well as the fine stone exterior resplendent with Hull Brewery's famous anchor sign.

36. The Botanic Inn, No. 231 Spring Bank, Hull

This, as well as much of the detail regarding The Polar Bear described earlier are largely based on the assiduous research carried out by Paul Gibson:

> We first hear of The Botanic from a sale notice run in the *Hull Advertiser* of 28 April 1871: 'to be sold by auction at the Polar Bear Inn, Spring-bank Hull. All that freehold messuage or dwelling house being no. 2 situate in Derringham Street, and the Beer-house and Confectioner's Shop at the corner of the same street, and fronting the Spring Bank.' (www.paul-gibson.com/pubs-and-breweries/spring-bank-pubs.php)

The wonderful timbers of the Botanic Inn.

Inset: The Botanic pub sign.

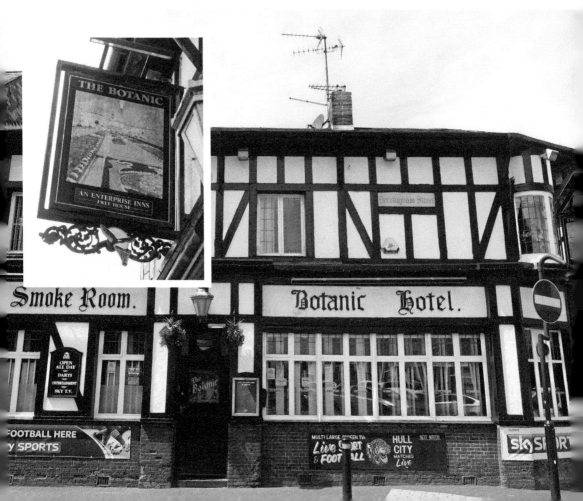

Miss Sarah Sissons is listed at the corner 'shop' – also as a confectioner – from 1874. By 1876 Miss Sissons had a beerhouse and was listed as a beer retailer in the directory; this was probably the first record of a pub on the site of The Botanic Hotel; however, by 1879 it was again listed as a confectioners. We know that George E. Cuthbert was innkeeper here from 1881, and the pub made its debut as The Botanic Hotel. The Hull Botanical Gardens moved from Linneaus Street to a site off Spring Bank West, just south-west of the beerhouse. The railway station nearby known as Cemetery Station, or Cemetery Gates, was renamed Botanic Gardens Station, while the new landlord named his pub The Botanic Hotel in keeping with his environs. The Botanic, being a Bass house, was the only pub on Spring Bank not owned by the Hull Brewery. The striking Gothic lettering on the exterior has survived.

37. The Queens, Queens Road, Hull

The hotel's website tells us that 'The Queens Hotel is a traditional pub built in the 1800s, a jewel in the crown of the local bohemian area of Queens Road … a popular and well renowned venue for local and colourful characters.'

The Queens – fit for bohemians.

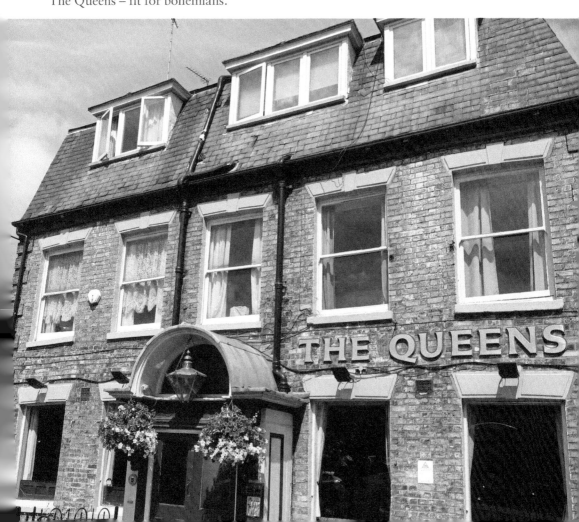

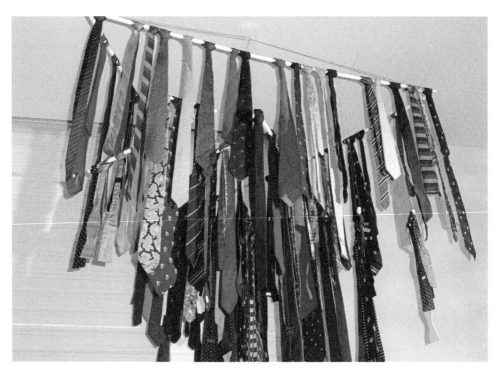

Philip Larkin's impressive range of ties, one of the exhibits in the excellent 'Larkin: New Eyes each year' exhibition in the Brynmor Jones Library, July–October 2017.

Equally impressive jacket, shirt and trousers at the same exhibition. They show Larkin to be a colourful character and so eligible to drink in The Queens, where in fact he often did.

Philip Larkin was allegedly one of these characters when he lived in nearby Pearson Park. You can see how colourful he was from the items of clothing bequeathed by the poet to the Brynmor Jones Library at the University of Hull, which featured in an exhibition held there in the summer of 2017.

38. The Haworth Arms, No. 449 Beverley Road, Hull

The original Haworth, just beyond the Newland Toll Bar, dated from 1800 and was first recorded in 1820. It was demolished in 1926 along with the toll bar. The new Haworth was

The original Haworth Arms in 1905.

The new Haworth Arms being built behind the old pub in 1927.

opened in 1927, is a listed building and competes for the substantial student market with The Gardeners Arms in Cottingham Road. It is probably named after the Brontë parsonage in Haworth. The musician Nick Drake once played upstairs, and the refurbished first-floor venue is now called Drake's Bar. In the 1970s, furniture from the pub could often be seen on late-night buses heading back to the student halls of residence at The Lawns in Cottingham!

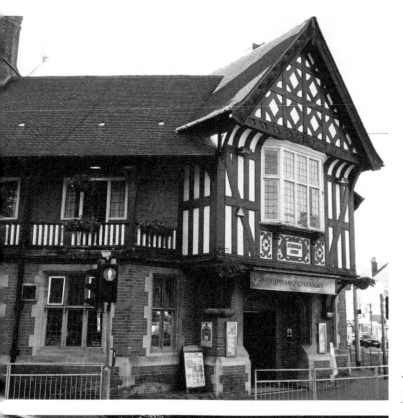

The Haworth Arms in June 2017.

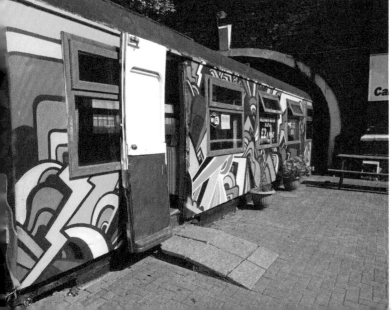

Cannon Junction – one of Hull's craziest and colourful pubs. A great place.

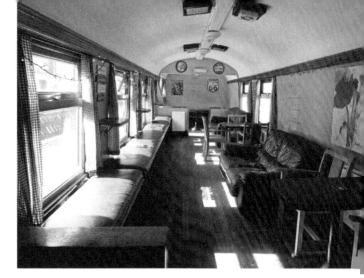

All aboard the Cannon
Junction Express.

The carriage corrider.

39. Cannon Junction, Railway Arches, No. 366 Beverley Road, Hull

When is a pub a railway carriage? When it is the Cannon Junction! This wonderfully quirky pub is essentially two former train coaches situated under the railway arches on Beverley Road. It opened in the late 1990s and long may it continue to serve.

40. The Harry Pursey, No. 386 Beverley Road, Hull

In November 2016, the *Hull Daily Mail* announced that the former Zachariah Pearson pub in Beverley Road would be reopening its doors as a new bar – but that children would not be allowed in this 'adult environment'. Amber Taverns Ltd completed the redevelopment of the former JD Wetherspoon's site, which was renamed The Harry Pursey after a former Hull MP, after talking to local residents, reviewing archives and old photographs. The Harry Pursey says, 'it operates a simple policy of creating an adult environment for social interaction by not providing food or allowing children into the pub'.

Commander Harry Pursey (1891–1980) was a British politician and veteran naval officer who started off as a boy seaman and served as a Member of Parliament for twenty-five years.

Pursey was elected as the Labour MP for Kingston upon Hull East in the 1945 General Election. In the 1951 election he held the seat with a majority of 11,500 votes, rising to 23,000 in the 1966 election. He was succeeded by John Prescott in the 1970 election.

Pursey married his second wife, Baroness Huszar, a Hungarian, in September 1954, in New Jersey. That same year she was arrested in Montreal for possessing counterfeit United States currency but was acquitted. She was arrested again in 1955, this time for the possession of drugs; she was convicted and the couple divorced in 1959.

Originally known as the People's Park, Pearson Park was the first public park to be opened in Hull, in 1860. The land was gifted by Zachariah Charles Pearson (1821–91) to mark his first term as Hull's mayor. Shrewdly, he retained around 12 acres of land on the periphery of the park to build some very desirable villas. Most have survived, including No. 32, owned by the University of Hull and occupied by Philip Larkin between 1956 and 1974. Two years later Pearson was undone after he bought, on credit, a fleet of ships to gun run through the Federal blockade during the American Civil War (1861–65). All of his ships were captured; Pearson was ruined and spent the last twenty-nine years of his life reflecting on his folly in a modest terraced house in a corner of the pleasant park that bears his name.

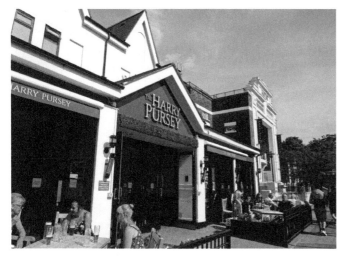

The Harry Pursey with its 'adult' environment.

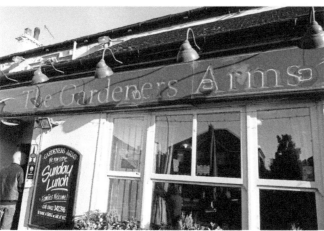

The Gardners Arms – resting place for many a student before a visit to the Haworth over the road.

41. The Gardener's Arms, No. 35 Cottingham Road, Hull

A popular pub with students and locals alike, this pub is close to the university campus.

42. Johnny Mac, Hull University Union, University of Hull, Cottingham Road, Hull

This University Union bar is named after Beirut hostage John McCarthy CBE, DLitt, (American Studies, 1979). Other alumni who would have graced the bar or its predecessor include Jill Morell – McCarthy's determined lifeline and tireless champion back in London and founder of 'Friends of John McCarthy' (FOJM); musicians Tracey Thorn and Ben Watt (Everything But The Girl); film director Anthony Minghella; poet Roger McGough; TV presenter Sarah Greene (*Blue Peter*, *Going Live*); Labour politicians John Prescott, Frank Field and Roy Hattersley; Jenni Murray of *Woman's Hour* and Radio 1 presenter Mark Chapman. McCarthy was a journalist working on a two-month posting with the WTN news agency at the time of his kidnap by Islamic Jihad terrorists in Lebanon in April 1986; he was returning from an assignment in Beirut when he was kidnapped on the way to the airport and was held in captivity until his release on 8 August 1991.

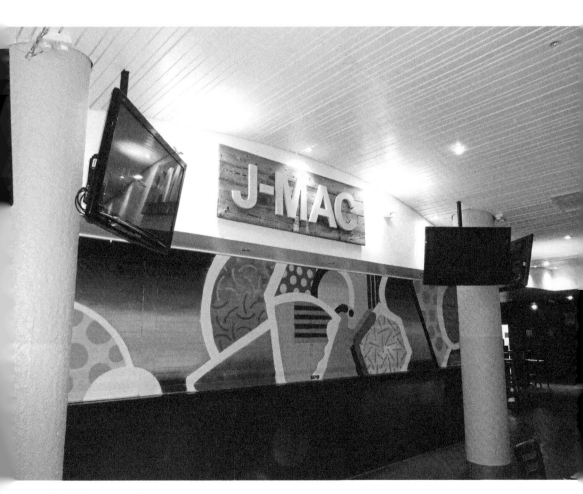

Hull University Union.

43. The Goodfellowship Inn, Cottingham Road, Hull

The Goodfellowship Inn was the first pub in Hull to install interactive Bluetooth technology for its customers. The pub has booths containing Bluetooth connections and television screens, which means customers can play their own music and watch films while they enjoy a drink or a meal. Whatever happened to socialising down the pub? The inn is famous for being Philip Larkin's local; but the poet is unlikely to have approved of the changes. When it was built in 1928, The Goodfellowship Inn was surrounded by fields and had a bowling green at the back.

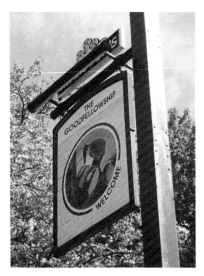

Left: Nice purple sign.

Below: Nice purple mock-Tudor timbers.

44. The Four Alls, Cottingham Road, Hull

The Four Alls' name derives from the four universal aphorisms: the king (or queen) rules for all; the priest prays for all; the soldier fights for all; the ordinary man or farmer pays for all. Another Four Alls stood on what was called the Holderness Turnpike Road from around 1840, with four statues representing the famous four. It changed its name to The Four in Hand in 1890 to reflect its status as a coaching inn. It was rebuilt in 1937 in mock-Tudor style.

45. The West Bulls, Bricknell Avenue, Hull

The unusual name derives from a farm whose land was built on to create that part of Cottingham Road. The pub is on the edge of West Hull; the farm was presumably noted for its bulls.

46. The Duke of Cumberland, Market Green, Cottingham

Leafy Cottingham is home to thousands of Hull University students and the many pubs here have enjoyed their custom and conviviality for many a decade. The Duke of Cumberland was not a nice man: Known as the 'butcher' Duke, on his victorious return from bloody Culloden Cumberland left a number of prisoners at Clifford's Tower in York in a perverted show of gratitude for the city's hospitality. The Sheriff's chaplain read out the message: 'And the Lord said unto Moses "Take all the heads of the people and hang them up before the sun".' Twenty-three people were duly left to hang for ten minutes, before being stripped and quartered, their heads chopped off and stuck fast on Micklegate Bar. Cumberland Street in York and this pub were both named after the Duke.

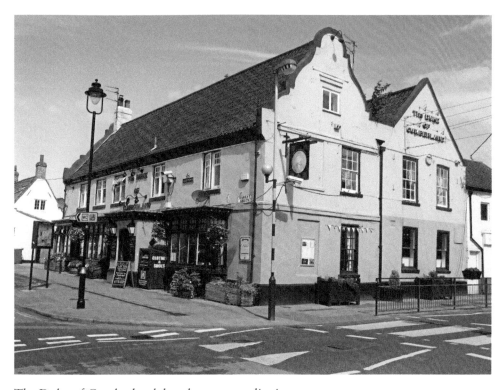

The Duke of Cumberland, butcher extraordinaire.

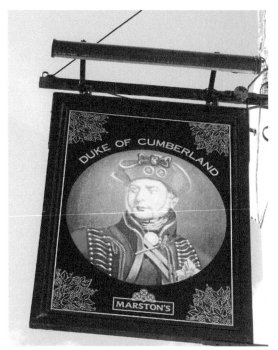

Here he is in up-close.

The Railway, Thwaite Street, Cottingham.

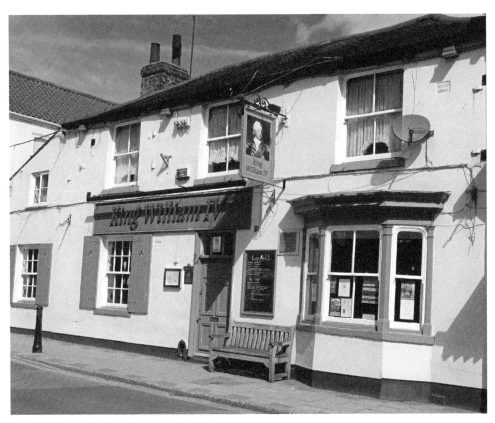

Above and right: King William IV, Hallgate, Cottingham.

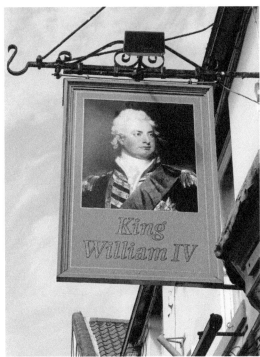

47. The Cross Keys Inn, No. 94 Northgate, Cottingham

Needler Hall was once opposite the inn, but the hall has since been replaced by a building site. Like The Haworth Arms on Beverley Road, The Cross Keys was victim to some low-level plundering in the 1970s when items of the pub's furniture and wall decorations found themselves beautifying the halls of residence just up the road at The Lawns.

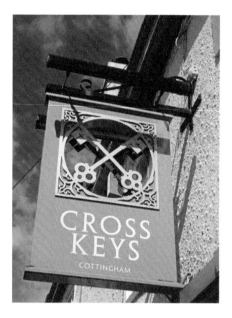

The Cross Keys – accidental home furnishers.

48. The Half Moon Inn, No. 16 Main Street, Skidby, Cottingham

The Half Moon Inn dates from the seventeenth century but the building was not always used as a pub; we know that in 1795 it was occupied by a weaver. There was a pub in 1810 in what is now Church Rise. Another Skidby pub, The Navigation Inn, was used by Irish navvies building the Hull and Barnsley railway in 1880–85 – it was probably no more than a hut on Bottom Road. Duckers Beer House was at 39 Main Street in 1900.

The Half Moon Inn experience is enhanced by the magnificent windmill here. The first reference to a mill in Skidby is in 1316: a simple post mill, financed by the Lord of the Manor and maintained by his tenant. The first record of a mill on the present site is from 1764; this mill was wind-powered and possessed two pairs of stones. In 1821 the mill was sold. The mill we see today is the last working mill in East Yorkshire, a four-sailed tower built in 1821. From 1854 until 1962 the Thompson family owned the mill, as well as a steamroller mill in Hull and a watermill at Welton, east of Hull.

Skidby Mill survived the Great Agricultural Depression at the end of the nineteenth century and was then given over to the production of animal foodstuffs by raising the mill tower, building additional outbuildings and installing new animal feed machines – changes which allowed the mill to thrive. The sails were disconnected and electric machinery installed in 1954; in 1974 the mill was fully restored to working order using wind power.

All of the original outbuildings are intact and form part of the fascinating Museum of East Riding Rural Life. The Agriculture Gallery displays the agricultural history of the East Riding, while the Village Life Gallery shows aspects of rural village life. There is also an intriguing

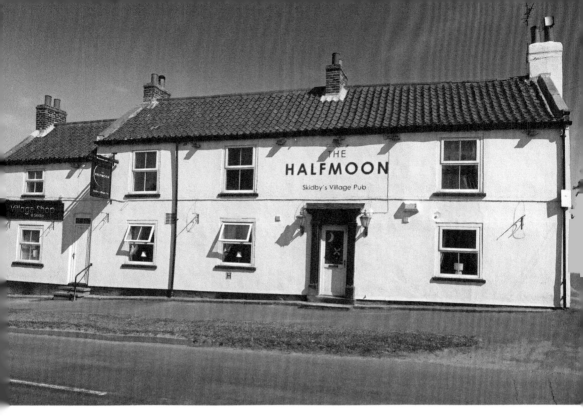

Skidby's village pub – all it needs is a windmill.

display of veterinary tools and restored animal feed machines; on the Flour Bagging floor visitors can see the major restoration work carried out on the mill between 2008 and 2010.

49. The Duke of Edinburgh, No. 1 Great Union Street, Hull
Originally called The Gate Beer House in 1850, thirty years later it was known as The Dock Coffee House. The Duke of Edinburgh in question was Alfred, Queen Victoria's second son, who came to Hull in 1884 to lay the foundation stone at Hull Royal Infirmary. In March 1930 the then landlord, Walter Garforth, was found dead in his bed. A maid walked into his room and found him strangled to death with a length of gas tubing. The inquest revealed that the maid was actually his niece; she had made him a cup of tea shortly before he took his own life. Her name was Florence Nightingale.

50. The Kingston Arms, No. 55 Thomas Street, Hull
Situated in the Strawberry Gardens district, this public house was built on the site of The Windmill Inn, then The Gardners Arms in 1800 and The Crooked Billet in 1820 – its sign is two pieces of wood fashioned into the shape of a St Andrew's Cross. Later names included The Sportsman and The Red House. The Kingston Arms was built in an ornate Italianate style in 1877. In its early days, Strawberry Gardens was a wonderful place with a vinery, cherry orchards, plum trees, currant bushes, skittle and quoit pitches. Sadly, the area degenerated into squalor, the haunt of robbers and whores. It was frequently used to hold public inquests into local deaths and was itself the scene of a tragedy in December 1907 when twenty-nine-year-old landlord Joseph Booth was found dead by his wife. An investigation uncovered empty laudanum bottles in the fireplace and a verdict of suicide was returned.

51. The Whittington & Cat, Commercial Road, Hull

A family run pub, it was originally managed by Samuel Wood in 1808, who passed it on to his son, Anthony, in 1841. Tragedy struck when Anthony's sister, Maria, died at the pub when she was just forty years old. In 1864, fifty-one-year-old Anthony walked into the brewhouse at the back of the pub and took his life. He was found hanging from a beam in what is now the rear bar. A jury returned a verdict of 'temporary insanity'.

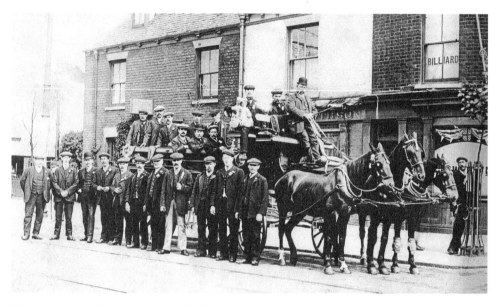

The Sportsman Hotel – this one in Hedon Road.

Hull Brewing

52. The Hull Brewery Co. Ltd 1888, Sylvester Street

Hull Brewery was taken over by Northern Foods in 1971 and then bought by Mansfield Brewery in 1985. Before that, however, in 1782, Thomas Ward and John Firbank built a brewery at the corner of Posterngate and Dagger Lane. Ann and Mary, Ward's granddaughters, inherited the brewery: Mary married a shipbuilder, Robert Gleadow, in 1796, and their son, Robert Ward Gleadow, continued with the brewing business. In 1846, Gleadow went into partnership with another brewer, William Thomas Dibb, to form Gleadow, Dibb & Co. Gleadow died in 1857 and was succeeded by his son, Henry Cooper Gleadow. William Thomas Dibb died in 1886 on a fateful train journey between Bridlington and Hull; he had run to catch a train at Bridlington, making the guard stop the train so that he could get on. By the time the train arrived in Driffield he was found dead, still sitting upright in his seat.

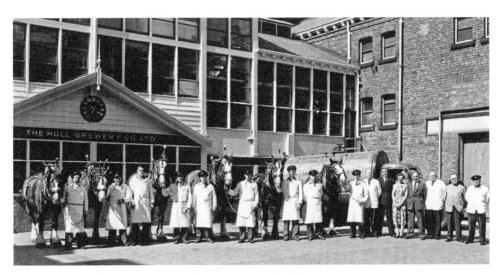

Staff at the Hull Brewery Co. Ltd outside their building in 1957; note the horses ready to haul the tanker.

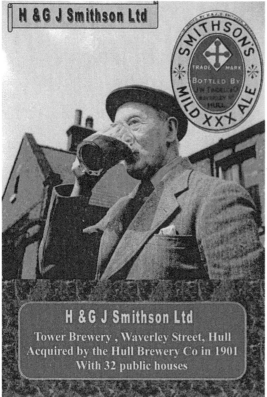

Above: Hull Brewery draymen.

Left: Another lovely pint of Smithson's ale.

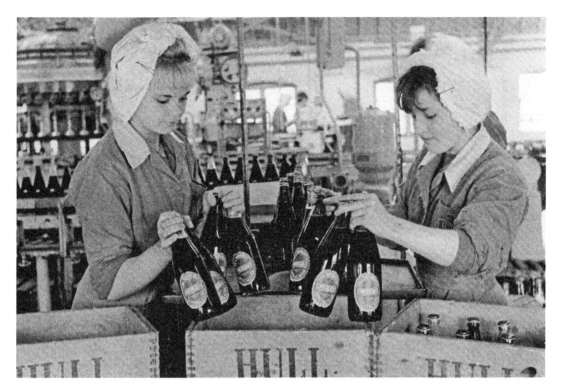

Hull Brewery Mild being packed into crates.

The year 1887 saw Gleadow, Dibb & Co. Ltd wound up, and the Hull Brewery Co. Ltd was born. Hull Brewery expanded its Sylvester Street brewery, acquiring other brewers and bottlers, and purchasing licensed houses: by 1890 they owned 160 licensed houses. In 1925 it acquired the Lincolnshire brewery Sutton, Bean and Company, with beer shipped across the Humber by barge. The brewery survived the Blitz, because the Luftwaffe pilots used its chimneys as a landmark. The year 1949 saw the company launch 'Anchor Export', a strong beer which kept and travelled well so that it could be taken aboard ships for refreshment on long voyages. In 1960 the brewery owned 206 pubs and thirty-nine off-licences in Hull alone.

Northern Foods took on 212 tied houses and changed the name to North Country Breweries Ltd in 1974. Sadly, Mansfield Brewery called time on brewing at Sylvester Street in 1985.

53. Moors' & Robson's Breweries Ltd, Crown Brewery, Francis Street, Hull

Moors' & Robson's were registered in March 1888 as Hull United Breweries Ltd to acquire Henry & Charles Moor, Crown Brewery and Edward Robson, Waterworks Street, at the price of £310,000. The name changed in June that year to Moors' & Robson's Breweries Ltd. In 1919 they took over Nesfields of Scarborough and Guy & Co. of Grimsby. In 1960, Grimsby got its own back when they were acquired by Hewitt Brothers Ltd of Grimsby, who closed them down along with their 138 tied houses.

The Guest Pub

54. Nellie's (The White Horse Inn), No. 22 Hengate, Beverley

As promised in the Introduction we have a guest pub – that guest pub is Nellie's in nearby Beverley. The website states: 'Please note: DOGS (with the exception of registered guide, or other assistive dogs), monkeys, any reptiles, ferrets, or fruit bats, are currently NOT allowed inside the premises,' which is not as daft as it sounds: the pub is a favourite haunt of hundreds of Hull University students every weekend in term time, so anything can happen here!

Before 1976, the pub was owned and run by the Collinson family. Frances Collinson bought the pub from the Church in 1927; her daughter, Nellie, managed the pub until its sale to Samuel Smith's Old Brewery of Tadcaster.

Nellie's was originally a coaching inn, thriving even before 1666. It is the second oldest surviving inn in Beverley, after The Sun Inn opposite Beverley Minster.

Nellie's possessively clings on to most of its original seventeenth-century features, including gaslights and chandeliers, small, intimate rooms, rickety stone and wooden floors, equally rickety chairs (I even remember sitting on upturned barrels in the 1970s, the very ones from which the beer was drawn by Nellie and her sisters), marble-topped tables, really old real books, vintage photographs, mottled mirrors and open log fires. The 'tobacco stained' walls are lovingly painted brown to faithfully recreate the tangible nicotine of those hazy pre-health-and-safety days of *laissez-faire* (and probably the only instance of artifice in the place).

The original well is in the entrance yard – sensibly gate-locked as 20-feet deep wells and alcohol make for an unwise cocktail. A few years ago, Jonathan Linthwhaite – aka 'Johnny Windows' – spent some quality time (reputedly twenty-four hours) down the well in aid of charity. Johnny was a big lad so there was little room for manoeuvre – draw your own conclusions about personal hygiene and natural needs. The tedium was relieved a bit by free-flowing showers of alcohol during opening hours.

The pub still has a linen press room with working press, and a scullery with a glass-fronted wall displaying a selection of receipts and invoices from local businesses dating back to the turn of the twentieth century. What used to be the non-smoking room has had its gaslights restored with real gas mantles – candles flickered away quite safely in the intervening

period. The family room (or Dart Room) boasts a well-used piano, an authentic old wine cooling chest and a dartboard, of course. The main bar is a no-children zone and has a bar: before the Sam Smith Age which ushered in relative modernity, there was no bar: drinks were served on tables scattered around the room, the wall clock is consistently wrong both in time and in chime.

The following are some press reviews:

It's hard to think of a pub with more history, character and heart ... aside from the building, what really makes Nellie's stand out are the incredible locals. They queue in the morning to get in, sit bantering all day, and fill the place with humour and warmth in the packed evenings. (*The Yorkshire Post*)

The beer used to come foaming, carried by Nellie herself or one of her sisters, robust women who weren't above heaving customers out on to the street if they got 'a mite too gobby'. Upstairs, some evenings, you could walk into a room stripped of everything except battered wooden chairs, and watch a group of veteran musicians playing brilliant, dusty old jazz on battered tin horns. Just like New Orleans... In a lesser place than Beverley, Nellie's would have been no more than a distant memory. But this little town ... has been so little touched by the ravages of the past three decades or has survived with such good grace. (*The Independent*)

The White Horse Inn, known to locals as Nellie's, in the well-heeled East Yorkshire town of Beverley is perhaps the closest you'll get to time travel in any pub in Britain... It is possible to spend a jolly pint or two chatting away with new friends. The sensation that you've whizzed back to 1860 is enhanced by the Dickensian murk of a spacious back room, made cosy by another fire. Sharing the room with a variety of curios – a linen-press, a cartwheel and an ancient cash register – patrons engaged in a classic pub conversation. 'Did you know that mahogany will sink if you drop it in water?' 'No, you're wrong. The only wood that will sink is *lignum vitae*.' For those seeking refuge from this flow of enlightenment, there are several snug retreats, each with its own volcanic blaze... the White Horse is like a mini-Gormenghast, with rooms rambling horizontally and vertically in every direction. When I first visited in the Seventies it was candlelit, and beer was dispensed from the barrel. (*The Telegraph*)

Nellie's – a touch of the Dark Ages.

Nellie's – still light years away.

Nellie's – twenty-first-century chic.

John White (left) and Les Almond (right) reading the Riot Act (1714).

Part Two

The Lost Pubs of Hull

Over the years Hull, like every town, city and village in the country, has lost countless pubs; this is a litany of some of those which, for reasons of economics, population changes, war or short-term commercial expediency have called time for the last time. They were once an integral part of the social fabric of their community. They define Hull life. Moreover, they demonstrate a number of aspects of the license trade: the ubiquity of micro-breweries attached to inns, the facility with which domestic houses were converted to shops which in turn graduated to become pubs, and the multi-tasking skills of the victuallers who often had other day jobs.

To start, here are some eccentrically named casualties:

Jack on a Cruise, North Street.
Tally Ho, Bond Street: a hunting cry and also a name for a stagecoach.
Tom Coffin, Humber Street.
Indian Chief, Blackfriargate.
Labour in Vain, Humber Street.
March of Intellect, Waterworks Street. This pub was once owned by two brothers who hired out their sons as climbing boys. The pub was then known as The Sweeps and the sign fittingly showed two sweeps with the tools of their trade. The sign was later annotated with the words 'the march of intellect' and became the official name.
Ship's Molly (*see* The Rugby).
B Sharp, Osborne Street.
Jack's Return, Grimsby Lane. Named after Ted Lewis' novel *Jack's Return Home,* which was made into the iconic *Get Carter* movie. Lewis lived in Barton-on-Humber and attended Hull Art School. He later worked on the Beatles' *Yellow Submarine* and the BBC drama *Z-Cars.*
The Pelican, James Reckitt Avenue. It is so named because it perched next to Earle's Cement Recreation Ground (Earle's logo featured a pelican).

In the 1800s there were sixteen Ship Inns in Hull, now there are three.

This chapter owes much to Paul Gibson's meticulously researched and unrivalled *The Lost Pubs of Hull,* now available online at www.paul-gibson.com/pubs-and-breweries/lost-pubs-of-hull

The Albany Hotel, Day Street

The Albany Hotel started serving in January 1874, thanks to a transferred licence from the closed Pilot Boy Tavern in Neptune Street, demolished to make way for the railways next to the docks. The Albany started off with a beerhouse licence but graduated to a full license freehold house when acquired by wine and spirit merchants Wilford & McBride who were later bought by the Hull Brewery Company. Locals called the pub 'Crossey's' before and after the Second World War, after John Cross, licensee in the 1930s. The pub closed around 1966 and was demolished during large-scale redevelopment of the area.

The Albany Hotel, Waterworks Street

This Albany was originally called The Blue Bell. It was an ancient inn dominating the corner of Blue Bell Yard, off Waterworks Street (now Paragon Street) since the late eighteenth century. The Blue Bell took the name The Carlton Hotel in 1874 but soon after, in 1888, the Albany name was restored and the building rebuilt. German bombing led to the pub closing on 8 May 1941 (the same bombing also destroyed the Prudential Buildings nearby). Its licence was suspended until 2 March 1953, when it was surrendered in favour of a full licence for the Albert Hall in Midland Street.

The Albert Dock Hotel, Commercial Road

Albert Edward, Prince of Wales, opened the Albert Dock in July 1869 at the east end of what was Castle Row, which was widened in response to the increase in trade and renamed Commercial Road. These alterations involved the demolition of the Dock Green School at the corner of Edward's Place. The Albert Dock Hotel was a grand three-storey building built in 1870 down the road from The Whittington Inn. On 15 October 1959 the Hull Brewery Company closed the pub and in 1990 it was demolished to make way for the Kingston Retail Park.

The Albert Hotel, Scott Street

This pub started life as The Sculcoates Arms – owned by brewers Gleadow & Dibb – on the corner of Scott Street and Carr Street. The name was changed in 1870 to The Albert Hotel to mark the death of Prince Albert in 1861. The Albert Hotel shut its doors for the last time on 17 December 1936 and was demolished shortly after. Its licence was inherited by the newly built Anchor Inn on Southcoates Lane.

Albert Hotel, Adelaide Street

This Albert Hotel won its first licence in 1851, following the closure of The Bath Tavern on the Humber bank. It was named after Prince Albert, who was in the news for opening the Great Exhibition of 1851. Its debut licensee was Joseph Wharam, who was also a brass-founder and gas-fitter. Handily, Robert Wharam, a brewer and licensed victualler of the Myton Tavern in nearby Porter Street, lived at the same address from 1863. Wharam ran a small brewery previously belonging to Robert Hesp from 1851 to 1863, at the rear of The Albert Hotel. Both The Albert Hotel and brewery was bought by Gleadow, Dibb & Co. in 1881, later to become a Hull Brewery Company pub. The hotel closed on 22 August 1949; its licence was transferred to a new pub called The Bridges on Sutton Road.

The Albion Hotel, Hedon Road

The Albion Hotel was established around 1867 by twenty-eight-year-old Robert Davy on the corner of Hedon Road and Williamson Street. It was a Gleadow & Dibb house, closing

on 9 May 1941 after sustaining heavy air-raid damage. Its licence was held in suspension until 23 June 1960, when it was transferred to *The Crooked Billet*, a new pub on the corner of Ings Road and Holderness Road.

The Alexandra Inn, Humber Street
The Alexandra Inn was originally called The Humber Tavern, located at the corner of Queen's Alley from 1805. The name changed in the 1860s to recognise the marriage of Princess Alexandra of Denmark to Albert Edward, the Prince of Wales in 1863. The Alexandra closed on 12 February 1927.

The Alexandra Inn, William Street
The first licensee was Edward Preston, who opened the beerhouse around 1840 in what had formerly been his coal merchant and grocers' shop. The pub was acquired by John Hunt's brewery, of nearby Waverley Street, and the freehold was acquired by the Hull Brewery Company in the 1890s. This Alexandra Inn closed in 1947; its licence was held in suspension until 1954, when it was surrendered for refurbishment to The New York Hotel.

The Argyle Hotel, Anlaby Road
Built around 1853, the hotel name is consistent with other properties in the vicinity with a royal theme. The Argyle also housed a wine and spirit merchant as part of the Henry Wilson & Sons chain. It was re-fronted and refurbished in 1930 in mock-Tudor style. It closed in 1967 and was demolished to make way for Rawling Way in the 1970s.

The Barmston Inn, Barmston Street
Barmston Street originally went by the much more descriptive name of Cotton Mill Street; it was renamed in 1863 in deference to a new estate of streets established on land once occupied by the Prince Albert Strawberry Gardens. The Barmston Inn was built on the corner of Barmston Street and Lincoln Street in 1870 and was owned by William Glossop, who had a brewery nearby. A Hull Brewery pub at the end, it closed in its centenary year, 1970.

The Barrel Tavern, Hill Street
The Barrel Tavern was converted from a dry-salter's' shop at No. 32 Hill Street in around 1878. Its large arch led to the houses in Furniture Square or Place. By 1916 the pub was referred to the Licensing (Compensation) Committee under the Licensing (Consolidation) Act 1910 and closed soon afterwards. The owners objected and complained of loss of revenue; they were paid a handsome £1,130 in compensation.

The Barrel Tavern, New George Street
Situated at the entrance to Nelson Square, this was a small one-roomed beerhouse established in the 1820s. It closed on 17 April 1928 and its licence was transferred to the newly built Goodfellowship Inn on Cottingham Road.

The Beverley Arms, Spencer Street
Spencer Street comprised low-rent, poor-quality housing to the west of modern Ferensway; it was home to many immigrant communities. The pub was first recorded in the 1820s as a beerhouse at No. 36. The construction of Ferensway did for it. The last victualler was ex-wrestling and weightlifting champion Tommy Bilham, who pulled the pints until the pub's closure in 1932.

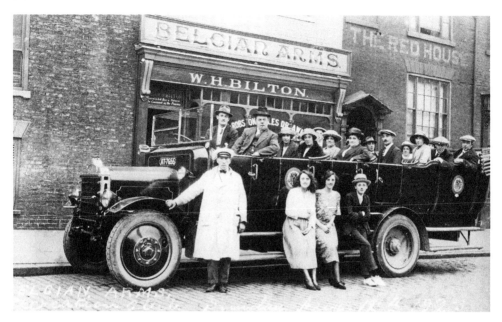

A charabanc about to set out for the Recreation Club Sunday outing, 12 August 1923.

The Black Swan, Princess Street/Dock Street

Dock Street was named after Hull's first dock in 1778, later Queens Dock, then Queen's Gardens from the 1930s. The Black Swan was at the corner of Princess Street (later Clifford Street) and Dock Street from the nineteenth century. This Moors' & Robson's pub closed following bomb damage on 7 May 1941, and the licence was suspended until December 1957. It was later transferred to a new pub on Ganstead Lane, Bilton: The Ganstead, later The Swiss Cottage.

The Blue Bell Inn, Thomas Street

An enterprising gardener called John Johnson owned Strawberry Gardens here in Drypool in the early nineteenth century. Around 1815 he built The Blue Bell on this site in Thomas Street, then known as Green Street. The Blue Bell stood opposite the entrance to Merrick Street and was one of ten pubs known as The Blue Bell in Hull at that time. In 1894 it was bought by Bass Ratcliffe & Gretton and rebuilt. This Blue Bell closed on 28 November 1932 and its licence transferred to the new Five-Ways pub on Boothferry Road.

The Bowling Green Tavern, Waltham Street

There was a bowling green on Waltham Street which gave its name to Bowling Green Court, which in turn gave its name to The Bowling Green Tavern in 1820. By 1930 much of the area was being demolished and the tavern closed. The site was taken on by British Home Stores (BHS).

The Builders Hotel, Cogan Street

Love Lane was this pub's first address in 1817, when it was called The Robinson Crusoe, changing its name around 1860 to the far less evocative The Builders Hotel. It was rebuilt

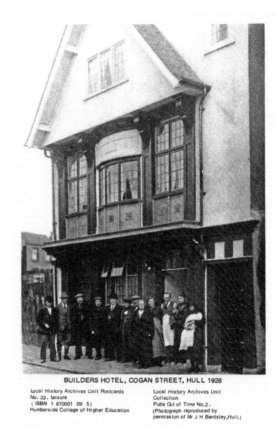

BUILDERS HOTEL, COGAN STREET, HULL 1928

Local History Archives Unit Postcards
No. 23. Leisure
(ISBN 1 870001 09 5)
Humberside College of Higher Education

Local History Archives Unit
Collection
Pubs Out of Time No.2.
(Photograph reproduced by
permission of Mr J H Bardsley,Hull.)

The Builders Hotel, Cogan Street.

in 1928 and closed in the mid-1960s, soon to be demolished. The short period during which the pub was called The Robinson Crusoe represents one of the few references Hull has ever made to Defoe's literary hero. Happily, there is now a plaque commemorating Robinson Crusoe in Queen's Gardens, which bears the inscription:

> Robinson Crusoe, most famous character in fiction, sailed from here September 1st 1651.
> Sole survivor from shipwreck he was cast upon a desert island where he spent 28 years,
> 2 months and 19 days. An example of resolution, fortitude and self-reliance.
> 'Had I the sense to return to Hull, I [would have] been happy'.

The Bull Inn, Beverley Road

For sale at the time of writing, the Grade II-listed Bull pub has stood at the corner of Beverley Road and Stepney Lane for more than a century. Built in 1903, the pub's striking design includes ornate exterior tile and brickwork, original etched windows and a prominent bull fixed to a corner wall. This gilded bull is thought to come from an older inn which occupied the same site. Other Beverley Road casualties include The Park, The Rose and The Station.

In 1851, the former landlord of The Bull, Thomas Moor, narrowly escaped being murdered by a pork butcher called William Miller. Miller had recently separated from Moor's daughter. He took a butcher's knife to Moor's throat before killing himself. Moor survived the attack and was later able to testify in court.

In March 1899, landlord George Henry Bearpark was found dead, in his first-floor bedroom, from a single shot to the head. A revolver was discovered near the body and a verdict of suicide was recorded.

The Burns Head, Waterloo Street
The Burns Head pub at 2 Waterloo Street was built in 1850 and by 1890 had taken over a butcher's shop next door. Around 1920 the old beerhouse front was sacrificed for a fashionable mock-Tudor black and white façade. The Burns Head was demolished in 1972.

The Cambridge Hotel, Great Thornton Street
John Welborn ran a grocer's at No. 2 Cambridge Street in 1872 and set up The Cambridge Hotel later that year at No. 114 Great Thornton Street – actually the same place as No. 2 Cambridge Street, situated as it was on the corner. This Hull Brewery pub closed in February 1959. Its licence was surrendered in favour of a full licence to The Sheffield Arms on Hessle Road.

The Carpenters Arms, Great Union Street
Our first record comes in around 1806 when Thomas England, the constable of Sutton and a cordwainer, was the first victualler. It stood between Coeleus Street and Hyperion Street. The pub was also called The Shipwright's Arms in the 1820s and '30s – both names reflecting local trades using the pub. The Carpenters Arms was decommissioned by Hull Brewery in March 1937 and was heavily bombed in 1941. The licence was transferred to The Elephant & Castle on Holderness Road.

The Cartmans Arms, Canning Street
This was also the North Myton Soup Kitchen in the early 1860s. The name probably originates from a previous tenant, Atkinson Miller, who was listed as a Hackney cartman in the 1861 census. The pub closed in November 1931.

The Citadel Hotel, Citadel Street
Listed in directories from 1867, this large pub was popular with workers from the nearby cattle yards, timber yards and docks; it was one of the few pubs at the south end of Drypool. The Citadel Hotel closed on 4 May 1960 and was demolished soon after.

The Clarence, Charles Street
This pub was established in 1872, when joiner George Ward was listed as the first victualler. A. Linsley & Co. beerhouse for many years, The Clarence did not receive a full licence until 1957, when the licence of the Grosvenor Hotel in Carr Lane was transferred after its demolition. The licence had been in suspension since 8 May 1941 when the Grosvenor was closed following Blitz damage. The Clarence was demolished in 1987, and the name was adopted by the 'new' Clarence built opposite.

The Coach & Horses, Mytongate
A particularly sad loss was this fine example of historical pub architecture. The Coach & Horses was one of Hull's leading coaching inns, with brickwork in the stables dating to 1660. A Bass pub with a model of an old coach and four kept behind the bar until closure in 1970, it was demolished in 1973 in the redevelopment of Hull's Old Town.

The Commercial Hotel, Castle Street

Tetley's Commercial Hotel was built around 1829 at the south end of Prince's Dock – once The Earl De Grey pub (named after the High Steward of Hull). Originally known as The Junction Dock Tavern, it was renamed in 1862. In 1895 the façade was rebuilt with the obligatory green-tiled Victorian frontage. Two macaws, Ringo and Cha Cha, lived here; in 1977 Ringo swore at a burglar and was throttled for his troubles. The Commercial was another victim of the Mytongate demolition programme in 1981.

The Commercial Hotel, Great Union Street

This Commercial Hotel opened around 1800 as a 'coffee house' but was as much an alehouse. The timber and shipbuilding yards close by provided the custom, as well as visitors to the Drypool Cattle Markets. In 1941 the Luftwaffe, following the line of the River Hull and targeting the Ranks Mills, also hit The Commercial Hotel, then a Hewitt's pub.

The Commercial Hotel, Cogan Street

A joiner called Peter Blenkin opened the Commercial around 1840 and was brewing here from 1851 to 1863. It was demolished in the late 1950s.

Corporation Arms, Neptune Street

The Corporation Arms was at the corner of Neptune Street and English Street; it opened around 1867. The licence came from the former Cattle Market Tavern in Wellington Street, which closed in the 1860s during the development of the new West Dock (Albert Dock). The first licensee was J. Everett from The Cattle Market Tavern. The pub became known as 'Chester's', after the Chester family, who were licensees of a number of public houses in West Hull and who ran The Corporation Arms on and off for over fifty years. The pub was demolished to make way for the expansion of the Smith & Nephew factories during the late 1960s and early '70s.

The Cromwell Hotel, Walmsley Street

On the corner of Walmsley Street and Shakespeare Street, it was first licensed in 1868 and initially belonged to brewers Kendall & Gruby, who bought the South Myton Brewery in Porter Street in 1876, renaming it the Exchange Brewery. In 1892 Worthingtons bought the Exchange Brewery and its estate of twenty-four pubs was broken up – including The Cromwell Hotel. The pub was still a Worthingtons house in the 1970s but had closed and been demolished by the early 1980s.

The Cross Keys Hotel, Market Place

The Cross Keys took its name from York Minster, which had a hostelry in this area in the fourteenth century; their coat of arms consisted of two crossed keys, which was the sign of St Peter and the keys to heaven. It was a thriving coaching inn from the eighteenth century, with forty bedrooms and fifteen sitting rooms, some of which were named after great national heroes such as Wellington, Nelson and Raleigh. The name on the front of the pub was Varleys Cross Keys Hotel, named after the Varley family, who had associations with the pub for over sixty years (Anne Varley was proprietor from 1859 to 1907).

The Cross Keys closed in 1922. A contemporary newspaper report of the time described it thus:

> It was a large and impressive four storied building with a double front and stabling for 40 Horses, to the rear was the great courtyard in which hung a bell dated 1596 along with

great branches of decorated ironwork from which the oil lamps swung when the steaming horses clattered in on a winter's night. In one of the courtyard buildings was a lovely Georgian bow window with a doorway next to it announcing a saving bank where the farmers left their money on market days.

The Crown & Cushion, Land of Green Ginger and Silver Street

The Crown & Cushion is really two separate pubs. The Crown was built in 1800; by 1823 it had been renamed The Crown & Cushion. In 1830 it was joined with The White Lion situated at 3 Land of Green Ginger, which had been built at the same time and backed onto The Crown & Cushion. It survived until 1876 when The Crown & Cushion part was demolished for the construction of the London and Yorkshire Bank (later the National and Provincial Union Bank and then the NatWest). The White Lion then took the name of the old Crown & Cushion. It closed on 3 September 1927; it was one of the few houses in Hull with an official singing licence.

The Crystal Hotel, Waterloo Street

A modish gin palace-style Bass pub first licensed in 1868, The Crystal Hotel was demolished in the early 1970s as part of a council compulsory purchase order which razed the whole district. The order took with it The Sculcoates Arms, Burns Head, Mechanics Arms, Pacific Hotel and others as collateral damage.

The De La Pole Tavern, Wincolmlee

In 1803 the site on the corner of Charterhouse Lane was home to a beerhouse known as The Jug. With the widening of Wincolmlee in 1840, The Jug was rebuilt and renamed The De La Pole Tavern. Along the north side of Charterhouse Lane the arched entrance led to the old malt kiln of the brewer's Brodrick & Peters. Hull Brewery Company took over the business in 1924; the tavern closed on Christmas eve in 1934 and was later demolished.

The Dog & Duck, High Street

A pre-1800 Worthingtons pub with its own brewhouse, this pub originally fronted onto High Street at the junction with Humber Street. The property to its right included another pub called The General Elliott, but this was demolished in 1863–64 to provide access for the South Bridge (Halfpenny Bridge) built in 1865. The name 'Dog & Duck' derives from the eighteenth-century 'entertainment' in which a duck's wings were tied before being thrown into the nearest pond or stream, only to have point dogs set upon it. The High Street could offer over fifty pubs at one time or another; at the time of writing there were just three.

The Dover Castle, Norfolk Street

James Barker Lording, a joiner, was the first licensee in 1851. This pub survived until the 1970s.

The Dover Castle Hotel, Hedon Road

Ralph Smith, a stonemason, opened a beerhouse at the corner of Merrick Street and Hedon Road in 1870; in 1877 a full licence was acquired when the redundant Regatta Tavern in High Street closed. The pub sported ornate brown-glazed tiles around the entirety of its frontage, while the serving counters were decorated with multicoloured ceramic tiles. The Dover Castle Hotel called time in the 1950s and the building was demolished in 2008.

The Drum & Cymbals, Osborne Street

Fittingly on Sibelius Road, this pub closed in 1956 when the licence was surrendered for the granting of a full licence to The Old English Gentleman. The Drum & Cymbals was one of ten pubs in Osborne Street in 1867.

The Edinburgh Packet, High Street

Earliest records of the pub indicate the pub was trading from the early nineteenth century, but it is probable that it was operating much earlier. The pub closed in 1929 following a purge on licensed premises in the old town; £3,000 was paid to the Hull Brewery Company to compensate for loss of business.

The Ferryboat Tavern, Wincolmlee

This pub was converted from a row of houses and shops south of Sculcoates Bridge in 1842, when Thomas Smith was listed as victualler. It is named after the many boats used to ferry workers from the Groves on the east side of the river to work in the factories in Sculcoates on the west side. From around 1873 to 1876 it was known as The Tiger No.5 when John Stephenson (or possibly George Stevenson, landlord of The Tiger No.1 in Waterworks Street) bought several inns and named them all The Tiger and a respective number. The Ferry Boat Inn closed on 17 December 1936 and was later demolished.

The Fisherman's Arms, Adelaide Street

It will come as no surprise that the pub name pays testament to the fishermen living and working in this area. A Hull Brewery beerhouse, it was established in 1872 by grocer Edward Brammer and closed in April 1958. Its licence was transferred to The Duke of Edinburgh in Drypool.

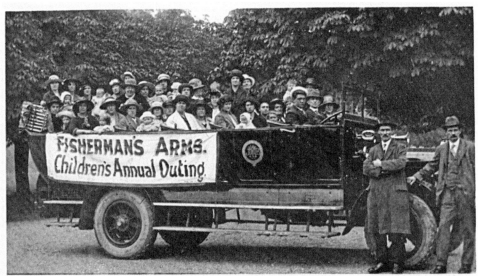

Local History Archives Unit Postcards No.49 Leisure (ISBN 1 870001 09 5) Humberside College of Higher Education

FISHERMAN'S ARMS CHILDRENS ANNUAL OUTING, 1922. MC MASTERS COACH IN PICKERING PARK, HULL.

Pubs Out of Time No.6 Original photograph by Duncan Photo 15 Anlaby Road, Hull, Reproduced by permission of Mrs.J.Brooke,Hull.

Fisherman's Arms' annual day out, 1922.

The Full Measure, Walton Street
Opened by John Norton in 1863 when its address was just 'Wold Carr', it was a Moors' & Robson's house. The green-glazed tile frontage was applied in 1907 to replace the original wooden façade.

The George Hotel, Whitefriargate
The building we know today as The George pub in the Land of Green Ginger is what is left of The George Hotel Tap, which stood to the rear of the bigger and grander rebuilt George Hotel at No. 66 Whitefriargate. This rebuilt George Hotel was the last of a long line of inns that had stood on the site since the seventeenth century, and it was the owners at the turn of the nineteenth century – the Wooley family – who rebuilt the hotel and tap. The main building survived until 1932, when the site was taken by British Home Stores in 1935.

The George & Dragon, High Street
The George & Dragon occupied a timber-framed property of fifteenth-century provenance or earlier; as an inn, though, our records are from the early eighteenth century. There was a small brewery at the back during the 1830s and '40s.

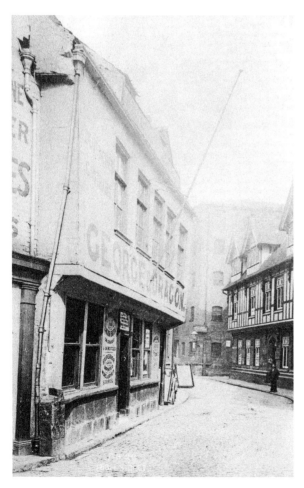

The George & Dragon.

The Golden Ball, Chariot Street

A typical small purpose-built Victorian beerhouse, it was first listed as a beerhouse with the name Golden Ball in 1876. In 1894 it was tied to Moors' & Robson's Brewery. In 1810 it was known as The Blue Ball, but by the 1880s the pub had become The Golden Ball. It was taken over by Hull Brewery in 1912.

The Grapes Hotel, Ferry Lane

The original Grapes here was at the old ferry crossing at Stoneferry, which ran from Clough Road across the River Hull to Ferry Lane. As with many ferries, there was a pub at one or both sides to refresh the ferryman and his thirsty travellers: in this case The Ferry House. When the ferry was replaced with a new bridge in 1905, the old Ferry House (often referred to as The Grapes as its inn sign was a bunch of grapes) was demolished to be replaced by a huge new pub in 1907, officially renamed The Grapes Hotel. Its glorious green-tiled façade was destroyed when the pub was demolished in 1986.

The Grapes Tavern, Chapel Lane

The Grapes is first recorded from 1817 and is one of around twenty pubs called The Grapes throughout Hull's history. The building was owned by the Hull Corporation and was early Georgian in origin. It closed on 30 December 1929 and the Combined Courts Centre now occupies the site.

The Grapes Tavern, Lime Street

Originally called The Barrack Tavern due to the soldiers based in the Hull Garrison further north in Lime Street and billeted in warehouses next to the inn. When the garrison closed it was known as The Grapes Tavern. The pub closed around 1960.

The Highland Laddie, High Street

This pub's first listing was in 1803, when it was known as The Golden Fleece. It was called The Fleece from 1826 until 1907, when it was renamed The Highland Laddie. The North End Brewery was adjacent at the end of the eighteenth century. The pub closed on 7 December 1961 and the new Highland Laddie on Southcoates Lane opened the same day, taking its licence.

The Holderness New Inn, Witham

This old pub was originally known as The Holderness Tavern, not to be confused with The Holderness at the corner of Dansom Lane. Dating from around 1800, the pub was later renamed The Holderness New Inn. The first landlord was a Richard Smithson, and in 1870 Gleadow & Dibb purchased the pub, rebuilding it in 1880. It closed in the 1970s and remained boarded up until the 1990s, when it was purchased and reopened as Doodlebugs, boasting a Second World War theme but with the same front and rear bar set up. Today the site has changed dramatically and is currently home to Jack Rabbit Slims bar.

Hope & Anchor, Cleveland Street

This small alehouse was first recorded around 1840. The original building was completely rebuilt in 1938, and in the 1970s it was absorbed within a new club known as Spiders nightclub.

The Horse & Jockey, Lower Union Street

Opened before 1814, The Horse & Jockey pub closed in 1908 and was demolished in the 1930s.

The King Edward VII, Prospect Street

Name changes characterise this pub. The Blue Bell was a late eighteenth-century inn that changed its name in 1876 to The Prospect Inn. In 1902 it took the name The King Edward VII, a Darley's house. It closed on 31 March 1941 following damage in the Blitz. The site was then taken over by Woolworths.

King William IV, Bond Street

Another pub with multiple name changes. First known as The White Horse, it was also called The King, The King's Head and The King William. Its licence was transferred in 1957 to The Tally Ho and then to the new Viking pub on Shannon Road.

The Leicester Hotel, Mytongate

This pub started life as a private house from 1791 and was converted to a hotel soon after. Originally called The Commercial Tavern, it became The Leicester Hotel in 1867. A Moors' & Robson's pub from 1899, it closed in 1967.

The Lily Hotel, Hessle Road

In the 1840s Thomas Wheatley, ginger beer and soda water manufacturer, left his business to his son William, who opened a beerhouse on the site naming it The Lily Hotel in 1874. It got its first full licence in 1953 when it took the suspended licence of The Windsor on Waterworks Street, which closed after sustaining damage during the Blitz of May 1941.

The Lion Inn, Francis Street

Built in 1825 as a private house, it later converted to a beerhouse. The Lion was first listed in 1863 as The Lion Tavern; it also had a bake-house at the back (this was the brewing area of an inn rather than anything to do with bread). After closure in 1949 its licence was transferred to The Kingston Hotel in Trinity House Lane. The Lion was demolished in the 1950s to make way for the Clover Dairies warehouse and factory.

The Lord Londesborough, Londesborough Street

Originally known as The Anchor and later The Paul Pry, this pub was renamed The Lord Londesborough around 1863 in honour of the colonel of the First East Yorkshire Rifle Volunteers. In 1864 the Hull Rifle Corps was allowed to rename what was then Waterworks Street, home to their Rifle Barracks, as Londesborough Street.

The Marlborough Hotel, Great Passage Street

The Marlborough Hotel was first recorded in 1810, when it was known as The Grapes. It was renamed The Marlborough in 1884 and was demolished in 1968.

Marrowbone & Cleaver, Fetter Lane

The delightfully named Marrowbone & Cleaver pub was described in a contemporary newspaper notice of 1817 as 'A new built dwelling house, used as a Public House, situate in Fetter Lane, and known by the name of the Marrow Bone and Cleaver'. Its name derives from the 'rough music' performed by butcher boys who held a marrowbone and cleaver, striking them to produce different notes as if they were bells. In the seventeenth century, married couples were often serenaded to such music. The pub closed in March 1957.

The Mechanics Arms, Liddell Street

This pub was first recorded in 1863 when Martha Turner-Ware was a beer retailer. The wonderful tiled frontage included diamond-shaped panels, each with a depiction of the various mechanics' skills. The Mechanics name refers to nearby Rose's iron foundry in Cannon Street.

The Milton Tavern, New George Street

Converted from a private house around 1860, the one-room Milton Tavern was enlarged to include a smoke room at the end of the nineteenth century. The Milton closed around 1928 and its licence was transferred, along with that of its neighbour The Barrel Tavern, to the new Goodfellowship Inn on Cottingham Road.

The Monument Tavern, Whitefriargate

This pub was also known as The Cross Keys and Turks Head from before 1778 until 1817, when it was re built. From the 1820s it was The Old Andrew Marvel, but it soon changed to The York Tavern and then The Wilberforce Wine Vaults, before finally being named The Monument Tavern around 1851. There was a model of the Wilberforce Monument on the first-floor window ledge above the pub sign. The pub closed in the 1960s.

The Myton Tavern, Porter Street

This was a Hull Brewery beerhouse which opened during the 1840s. The first licensee, Robert Wharam in 1846, also had a small brewery at the back of the Albert Hotel in Adelaide Street and was probably related to the Wharam family who ran The Albert Hotel at that time. The Myton Tavern was known as Freddie Fox's after a popular licensee in the 1930s. After sustaining damage in the Blitz, the Myton Tavern was closed and the licence held in suspension until 1951, when it was transferred to the new Mayberry pub in Maybury Road.

The Nag's Head, Holderness Road

In the late eighteenth century, this pub was called The Summergangs New Inn, but it was known as The Nag's Head by 1810. It was sold that year as part of the estate of bankrupts Thomas Railey and James Hunt, brewers at the George Yard brewery. Other pubs sold off were The Sir Ralph Abercromby in High Street, Kings Arms in Witham and Opening of the Dock in Blanket Row. Worthingtons purchased all the freehold licensed property from William Smith in 1922, an ex-brewer of the Victoria Brewery. The £70,000 he was paid secured for him The Nag's Head, Kingston Arms, Druids Arms, Buck Inn in Beverley, Highland Laddie, Station Hotel in Howden, Number One, Moulders Arms in Beverley, Crown Inn in Paull, Newbegin Arms, Four in Hand, Blue Bell in Ellerby and The Kings Head in Nafferton. The Nags Head closed in 1986 and was demolished in 1987 during clearance works for the building of Mount Pleasant.

The Neptune Arms, Neptune Street

First recorded in 1817, and known locally as Little Neppy, this pub was owned by the Hull & Barnsley Railway Company. Brewers Kendall & Gruby renamed it The Exchange Brewery in 1876 (the brewery was next to the Portland Arms in Porter Street). In 1892 Worthingtons bought the brewery and the estate of twenty-four pubs, which included Railway Tavern, Queen's Head, South Myton Tavern, Shipwrights Arms, Reefer, Crown & Cushion in Land of Green Ginger, Neptune Tavern, Oriental, Cromwell Hotel, Plumbers Arms in Dagger Lane, Juno, The Queen in Charlotte Street, Norwood Arms, Mason's Arms, Red Lion, Linnet & Lark, Dog & Gun, Earl Cardigan in Fish Street, Alexandra and The Albert Hall in Midland Street.

The Neptune building today.

Inset: The famous blue plaque.

The Neptune Hotel, Whitefriargate

One of eight pubs or hotels in this short street in 1900, this was one of Hull's most prestigious hotels and the original Custom House built in 1797 by Trinity House, which still owns the five-storey Georgian building and was built to serve merchants disembarking at the city's first purpose-built dock. There were twenty-two rooms when it was a hotel, each boasting a four-poster bed. High rents, caused by taxes imposed during the wars with France, led to its demise as a hotel, but by 1815 it was leased out as the city's Customs House until 1912. You can still see the magnificent maritime carvings on the well-preserved façade, including a carving of Neptune's head and the upturned anchor of Hull Trinity House's coat of arms. Inside, the carved ceilings of the Adamesque-style banqueting hall with intricate designs of musical instruments, bows and arrows, and emblems of the sea are a delight. Lewis Carroll's grandfather worked here.

The North Bridge Hotel, Witham

An inn has stood on this site near the bridge over the River Hull since the end of the eighteenth century. This pub was known as The Jolly Sailors in 1803, and The Holderness Tavern from 1805. In 1941 it was damaged in a bombing raid and closed on 9 May 1941. In 1959 the licence was transferred to the new Mermaid pub in Bethune Avenue.

The Norwood Arms, Osborne Street

Charles Morgan Norwood was a local shipping tycoon and one of two Liberal MPs for Hull in 1865. Norwood was also a devout temperance man, so it seems that the naming of this pub was a mischievous act to say the least. It was a Victorian conversion of a former butcher's shop opened after 1863; following substantial damage during the Second World War its licence was placed in suspension in 1942, then surrendered to The Dairycoates Inn on Hessle Road in 1957.

The Old Black Horse, Carr Lane

Dating back to at least 1790, Timothy Reeves, a brewer and victualler, probably brewed on the site of the Black Horse which suffered severe damage following bombing on 24 November 1941 and was subsequently demolished. There was a special removal of its licence to a former shop at 6 Porter Street – a building which had been occupied by various businesses in its time, including in 1930 the Tetrarch Cycle and Gramophone Co. Ltd and from 1936 Miss Florence Kirkwood, gown specialist. During the 1870s the building had been refreshment rooms. The new pub converted from the shops was also named The Black Horse, a Hull Brewery pub when it closed in 1962. The licence was then transferred to the newly built Spotted Dog on Inglemire Lane.

Old Greenland Fishery, Wincolmlee

Converted from houses in the early 1820s, its name refers to the Arctic whaling ships, many of which were built and sailed from the Greenland Yards in the area. The 'Old' part of the name was added around 1882, to distinguish it from another pub of that name. The pub closed in 1933 and its licence was transferred, along with that of The Railway Inn on Hedon Road, to the new Endyke Hotel on Endike Lane.

The Ordnance Arms, Great Union Street

The Ordnance Arms opened in 1810 and was originally much smaller until it was bought by the brewer William Glossop in 1884, who extended into the shop next door. Ironically given its name, this pub received a direct hit on 9 May 1941 and what was left was demolished soon after. The licence was eventually transferred to The Star of the West on West Street.

The Oriental Hotel, Hedon Road

This pub received its first licence in 1881 when The Brotherton Tavern in High Street closed down. The name Oriental was a reflection of the varied nationalities of its clientele, many of whom would have been foreign seamen from ships in the docks or migrant workers. On 8 May 1941, a direct hit by the Luftwaffe destroyed the pub. A new Oriental was built opposite but was demolished in 2000 to make way for Hedon Road improvements.

The Prince of Wales, St James Street

St James Street was called Cent Per Cent Street until 1831 and located between English Street and St Marks Square – an area known as The Pottery. In 1926, Martin H. Cross was the victualler; his name was etched into the window glass. Cross also owned a brewery in Osborne Street and The Prince of Wales was a retail outlet for his ales. The brewery was taken over by Gleadow & Dibb in 1887 and subsequently became part of the Hull Brewery Company. The pub was popular with workers from the engineering factories and railway yards along English Street but closed in August 1960. Its licence was then transferred to The Albion Hotel on Caroline Street.

The Punch Hotel, Queen Victoria Square

The original Punch was at the back of the present Punch Hotel from 1845. In 1894–95 this building was demolished and rebuilt by the Hull Brewery Company. The new pub opened in 1896 and is still serving today.

The Queen, Prospect Street

This pub was demolished as part of the development of Queen Victoria Square.

The Queen's Arms, Junction Street

After the building of the Wilberforce Monument near Monument Bridge in 1834, a beerhouse opened on the corner opposite – appropriately named The Monument Tavern. After the accession of Queen Victoria, Mr Weddell-Headley, the then victualler, changed the name to The Queen's Arms around 1837. The pub, and everything around it, was acquired by Hull Corporation at the end of the nineteenth century and demolished to allow the construction of Queen Victoria Square and the City Hall. Following this the pub's licence was transferred to the City Hall.

The Queen's Head, Walker Street

The Queen's Head was built in 1858 and granted a full licence when the licence of The Brown Cow on Anlaby Road was transferred around 1863. It was rebuilt in 1907. The pub was popular with artistes visiting the nearby Palace Theatre and American servicemen during the Second World War. It closed on 12 June 1958 and was demolished in 1967.

The Railway Inn, Hedon Road

George Thompson, a victualler at The Blue Bell pub in Thomas Street over the road, opened The Railway Inn, naming it after the nearby Victoria Railway terminus. The Railway Inn closed on 7 December 1933 when its licence – along with that of The Old Greenland Fishery in Wincolmlee – was transferred to The Endyke Hotel.

The Rampant Horse, Mytongate

Originally known as the Full Measure, by 1826 it was The Rampant Horse, a name derived from the coat of arms of a previous owner of the property, or from the use of the land on

Local History Archives Unit Postcards
No.28, Leisure
(ISBN 1 870001 09 5)
Humberside College of Higher Education

RAMPANT HORSE PUBLIC HOUSE,
MYTONGATE, HULL

Pubs out of Time No. 3.
Original photograph by Ted Tuxworth,
Hull mid 1960's.

The Rampant Horse.

which it stood. The pub closed in 1966; in 1989, the demolition squad clearing the pub found an old cockpit. There was another Rampant Horse rampaging in Paisley Street from 1866.

The Rising Sun Inn, Campbell Street

When Campbell Street was laid out around 1860, this beerhouse was made from a conversion of two small houses. The pub served its last in August 1962; the licence was transferred to a new pub also known as The Rising Sun on Beverley Road.

The Robin Hood Hotel, Myton Place

The Robin Hood, or Robin Hood & Little John as it is also known, was established just before 1800 and was initially a wine and spirit stores. It was demolished in 1968.

The Rose Tavern, Hessle Road

The Rose Tavern was established in 1863 in Alfred Street as a licensed ale and porter store run by Dennis Taylor, who doubled as licensee of The Sheffield Arms on Hessle Road. From the 1880s Tate's Brewery of Lime Street in the Groves owned the Rose; the pub was rebuilt when the company was acquired by the Hull Brewery Company in 1896. The new building was three storeys high with Dutch gables and was demolished in 1969–70 under a compulsory purchase order for the area, which also did for The Lily Hotel and The Foundry Arms.

The Sculcoates Arms, Charles Street

The Scully Arms, as it was known, boasted one of the most attractive pub fronts in Hull and is a tragic loss to the city. The property was built between 1838 and 1842 and was known 'by the sign of The New Inn' when sold in 1849. It had its own brewing facilities then. The pub was refurbished in the 1890s when its famous ceramic-tiled exterior was added. Inside, the bar was finished in white-glazed tiles. Women were verboten and had to sit in the snug – entered by a side door. During the 1930s the pub was known locally as 'Smokey Joe's'. It had a brass pixie which had a permanently lit flame for smokers and a stove in the corner with a pan of peas usually warming on the top. The pub closed on Sunday, 9 April 1972 and was finally demolished in 1983.

The Sculcoates Arms.

Local History Archives Unit Postcards
No.29, Leisure
(ISBN 1 870001 09 5)
Humberside College of Higher Education

THE SCULCOATES ARMS PUBLIC HOUSE,
CHARLES STREET, HULL

Help! Conservation Action Group
Collection, Pubs out of Time No. 4.
Original photograph, no date.
Reproduced by permission of

The Sculcoates Commercial Hotel, Wincolmlee
This pub was situated in warehouses on the east side of Wincolmlee from 1838. In June 1937 the rear outbuildings – which had just been rebuilt following damage by a moored ship – collapsed into the river. Originally a Hunt's Brewery house, it was bought by the Hull Brewery Company in the 1880s.

The Seedcrushers Arms, Francis Street
Sculcoates was the centre of Hull's most important industry, oilseed crushing, and many of the workers in the oil crushing mills would have lived near this pub in Sculcoates.

The Shakespeare Hotel, Humber Street
When the Theatre Royal opened in Humber Street in 1810, it provided the inspiration for the name of this pub which opened that same year. During a 1890s refurbishment, six carved heads of Shakespeare were added to façade. The Shakespeare Hotel closed after the Luftwaffe inflicted heavy bomb damage on 9 May 1941. Its licence was suspended until 2 March 1953, when it was surrendered to The Dover Castle pub on Hedon Road.

The Ship's Hold, Wincolmlee
The Ship's Hold in Wincolmlee was first recorded around 1822. It was rebuilt in 1904, when the tiled frontage was added. The door on the left of the building led to the bottle and jug area.

The Shipwright's Arms, Marvel Street
Another ship-related pub which was originally built in 1810 as two shops, one of which later became this beerhouse around 1826. The Shipwright's Arms suffered bomb damage during the Blitz and was demolished in the late 1940s.

The Southcoates Station Hotel, Holderness Road
Sited opposite the former Corn Mill Hotel, William Glossop & Bulay Ltd, brewers and maltsters, purchased and enlarged the premises at the end of the nineteenth century and named it The Southcoates Station Hotel after the nearby station on the Hull to Withernsea line. The hotel was bomb damaged during the Blitz and closed on 18 May 1941; the licence was held in suspension until 1961, when it was transferred to the new Pelican Hotel on James Reckitt Avenue.

The St Leger Hotel, Paragon Street
Originally known as The Druids Arms, from 1863 it was later renamed after the horse race. The pub closed in 1923, when it was a Moors' & Robson's house, and was sold at auction in 1925. The property was latterly a Yates Wine Bar, developed in premises next door, formerly The White House Hotel.

The Stag Inn, Leonard Street
Originally owned by brewers Warwick & Richardson of Newark-on-Trent, this tiny pub was previously a grocers and tea-dealers shop. It was first recorded as a beerhouse in 1862, when John Craven was the beerhouse keeper. It endured until 1976, a longstanding John Smith's pub.

The Star of the West, West Street
This was originally a three-storey house built around 1788 with a small front garden. The name was probably a seafaring reference, a nod to the many star-gazing sailors who lodged

in the area. Or it may just be because it was in West Street. It was converted to a grocer's shop in the early nineteenth century and then to a small beerhouse in the 1870s. It acquired its faux half-timbered façade in 1926–27.

The Swan Inn, Mytongate
Originally The Black Swan, this Georgian beerhouse became known as The Old Swan at the turn of the twentieth century. In 1915 the pub ceased trading, after which it became a lodging house belonging to wine and spirit merchant Evelyn Cooke. After that it was the wholesale outlet for West Hartlepool Cameron's Brewery in Hull, who painted the old black swan inn sign white. The pub and everything around it was demolished in the 1970s.

The Swann Inn, Beverley Road
The Swann Inn began as a house with a front garden and then became a shop; it was first listed in 1876 under beer retailer Joseph Nattriss, and in 1898 it was rebuilt by local builder Mr Goates as a Moors' & Robson's Brewery house. Mr Goates was obviously a man of some taste: the façade featured faience tiles by Burmantofts. In 1900 The Swann was granted a full seven-day licence when the licences of The Foresters Arms in Finkle Street and The Flying Horse in Sewer Lane were surrendered.

The Theatre Tavern, Dock Street
First known as The Norwegian Tavern, from 1806, its name changed to The Theatre Tavern in 1893 to mark the opening of the Grand Theatre in nearby George Street. It was demolished in 1974, along with the Field's Café in Savile Street, to allow for the construction of the former Norwich Union Insurance building.

The Tigress, High Street
This pub was situated on the corner of Blaydes Staithe, opposite The Highland Laddie. The inn is recorded in deeds of 1734 and was first known as The Blue Ball – one of many names which also included The Ball, The Full Measure, The Corn Exchange Tavern, The New Exchange Tavern and finally The Tigress Inn around 1867. The Tigress was a Moors' & Robson's pub from 1894; it was demolished shortly after closure in 1971.

The Victoria Tavern, Chapman Street
The Victoria Tavern started life as a drinking booth, a kind of pop-up pub, within the pleasure gardens known as the Victoria Tea Gardens. Dating from 1834, the first beer retailer there was William Collinson, a beer retailer and gardener in Sutton Row in 1862. These gardens also featured a dancing booth. The beerhouse licence survived the closure of the gardens, and the Victoria Gardens was officially a 'public house' by 1851, with rooms including a dram shop. Known then as The Victoria Tavern – a Linsley & Co. house – it was rebuilt in 1900. The expansion of the Reckitt–Benckiser estate meant the end of The Victoria Tavern in 2001; it was sacrificed to make way for a car park entrance.

The Victoria Vaults, Anlaby Road
The Victoria Vaults was next door to one of Hull's most popular dance halls – The Circus. It was a beerhouse and part of the business belonging to bottler and wine and spirit merchant James Southam. The Hull Brewery Company acquired the bottling business – but not the licence or the pub – in 1948 and maintained the pub until closure in 1970. It was awarded its first full licence in March 1953 when the licence of The Dock Arms, Dock Office Row, which had been in suspension since 1941, was transferred there.

The West Dock Hotel, English Street

The early nineteenth-century West Dock Hotel was first known as The Baltic Tavern. The *Hull Advertiser* of 14 July 1804 brought some sad news regarding an auction 'at the house of the Widow Griffin known by the sign of the ship and commonly called the Baltic Tavern'. Mr John Griffin, her late husband, was the first known victualler at the pub from 1803. With progress being made on the construction of Albert Dock during the 1860s, The Baltic Tavern's name was changed to The West Dock Hotel. It was known as 'Pops', after Thomas Poppleton, a popular licensee from the 1930s to the 1950s. The pub closed on Friday, 4 June 1976 after irreparable structural faults were discovered.

The Western Tavern, Alfred Street

Another early nineteenth-century pub, The Western Tavern began life as The Gate Inn and is mentioned from 1810. Following refurbishment around 1860, The Gate Inn was renamed The Western Tavern, but it could not compete with the more popular Inkerman Tavern next door and closed on 12 February 1927. The site was then sold to Moors' & Robson's, who owned The Inkerman Tavern and demolished both pubs in order to build a new pub which they called The Inkerman Tavern.

The Wheatsheaf Hotel, King Edward Street

This pub was originally called The Mill Inn after the eighteenth-century windmill which stood on the corner of what is now King Edward Street and Waltham Street. The mill was known as Waltham's Mill – giving Waltham Street its name. By 1822 The Mill Inn became known as The Wheatsheaf Inn; its sheaf of wheat inn sign and was often associated with the baking trade and with agricultural trades. Around 1840 Charles Searby, a bricklayer and builder, took over and changed the name to The Wheelrights Arms, reverting to The Wheatsheaf Inn around 1851. It was popular with Merchant Navy radio officers, who, when in port, called it The 2182 Bar – a reference to the radio-telephone calling frequency of 2182 kilocycles. The Wheatsheaf closed in 1972.

Th' Whig Mug House, Whitefriargate

Mug houses were, and still are, pubs in which your very own mug was hung over the bar or in the window waiting for you. During the first Jacobite Rebellion from around 1716 Whigs established politicised tavern clubs (or mug houses) 'as vehicles to counterpoise a pro-Hanoverian presence, and these houses became an obnoxious presence to Jacobites wont to attract violent attack. Mug House Whigs and Jacobite/Tory mobs bloodied the flagstones with street brawls in 1715–16, not neglecting to sing taunting partisan doggerel at one another.'

This one was to be found,

> ...downe Mug House Entry': this entry is about 5 foote wide an' about a score o' strides long. At the extreme is an olde ale House wi' th' signe-bord of a Quart Mug over the Doorsteade, an is kept by a man called Benjamin Gaskin, or Sancho Ben as a Nickname. Th' Whig gentlemen yn Hull...begun to forme these Nests...At the' Dens – what yy calle Free & Easy clubs are heldid, so yt th' whig supporters can take they're Mug of Ale, talke Politiks, make speaches, play Cardes, Merrils, Knacks an' other Hand games.

There were other mug houses in Trinity House Lane and Low Gate.

The White Lion, Collier Street

The original White Lion stood was first known as The Bricklayer's Arms thanks to its first landlord John Wass, a builder and bricklayer. In 1875 it was renamed The White Lion. The original White Lion was said to have been a popular haunt for infamous Victorian criminal Charles Peace, who, it was said, was involved in a rooftop escape across Hull after being found drinking at the pub. It was known at one time as The Green Gingerman.

The Windsor Hotel, Waterworks Street

Built in the late 1700s on the corner of Chariot Street, it was first mentioned in Clayton's directory of 1803 as The Tiger public house, with Mrs Sarah Mercer as victualler. Around 1826 The Tiger became known as the The March of Intellect and locally as The Sweeps due to its unusual inn sign. It was taken over by Worthingtons in 1900, given a new façade and renamed The Windsor Hotel. It was damaged in the Blitz and closed on 8 May 1941.

The Zoological Hotel, Beverley Road

The building that later became The Zoological Hotel (The Zooey) appeared in the Hull Advertiser in July 1815 as 'the house of Mrs Dunn – known by the sign of the Ship'. In 1840 The Ship was renamed The Zoological Hotel, taking its from the short-lived Zoological Gardens on Spring Bank that opened that same year, or perhaps from the zoological collection held in the original Botanical Gardens on the Anlaby Road. Sadly, The Zooey closed its doors on 2 March 1985, but many still remember its rickety wooden floors and warm atmosphere.

Here is a fitting place to end, as The Zooey was my local when I lived in Harley Street, while The Polar Bear was my local when I lived in Sunny Bank. Animal magic!

'Will someone [now] take me to a pub?'

G. K. Chesterton (1874–1936)

The 'Zooey'.

List of Pubs and Breweries

1. The Minerva, Nelson Street, Hull, HU1 1XE, tel. 01482 210025, website: www.minerva-hull.co.uk
2. Humber Dock Bar & Grill, No. 9 Humber Dock Street, Hull, HU1 1TB, tel. 01482 591961, website: www.humberdock.com
3. The George Hotel, No. 1 Land of Green Ginger, Hull, tel. 01482 226373
4. Ye Olde White Harte, No. 25 Silver Street, Hull, HU1 1JG, tel. 01482 326363, website: www.yeoldewhiteharte.com
5. The Lion and Key, No. 48 High Street, Hull, HU1 1QE, tel. 01482 225212
6. The King William (King Billy), No. 41 Market Place, Hull, HU1 1RU, tel. 01482 227013
7. Ye Olde Corn Exchange, Nos 1–4 North Church Side, Hull, HU1 1RP, tel. 01482 323 741
8. The Blue Bell, Nos 54–56 Market Place, Hull, HU1 1RQ, tel. 01482 324382
9. The WM Hawkes, No. 32 Scale Lane, Hull, HU1 1LF, tel. 01482 224004, website: www.wmhawkes.co.uk
10. Walters, No. 21 Scale Lane, Hull, HU1 1LF, tel. 01482 224004, www.waltersbar.co.uk
11. The Manchester Arms, No. 7 Scale Lane, Hull, HU1 1LA, tel. 01482 323864
12. The Manchester Hotel, George Street
13. Ye Olde Black Boy, No. 150 High Street, Hull, HU1 1PS, tel. 01482 215040, website: yeoldeblackboy.weebly.com
14. The Sailmakers Arms, Chandlers Court, No. 159 High Street, Hull, HU1 1NQ, tel. 01482 227437, website: http://thesailmakersarms.com/
15. The Head of Steam, No. 10 King Street, Hull, HU1 2JJ, tel. 01482 217236, website: www.theheadofsteam.co.uk/
16. The Bonny Boat, No. 17 Trinity House Lane, Hull, HU1 2JA, tel. 01482 224961
17. The Kingston Hotel, No. 25 Trinity House Lane, Hull, HU1 2JA, tel. 01482 223635
18. The Mission, Nos 11–13 Posterngate, Hull, HU1 2JN, tel. 01482 221187, website: www.oldmillbrewery.co.uk/the-history.html
19. The City Hotel, Alfred Gelder Street, Hull, HU1 1EP, tel. 01482 591900
20. The White Hart Hotel, Alfred Gelder Street, Hull, HU1 1HB, tel. 07979 863815
21. The Three John Scotts, City Exchange, Alfred Gelder Street, Hull, HU1 1XW, tel. 01482 381910

22 The Burlington Tavern, No. 11a Manor Street/Alfred Gelder Street, Hull, HU1 1YP, tel. 01482 229031, website: www.burlingtonandstarofthewestpubs.co.uk

23 The Empress, No. 20 Alfred Gelder Street, Hull, HU1 2BP, tel. 01482 326839

24 The Punch Hotel, Queen Victoria Square, Hull, HU1 3RA, tel. 01482 325245, website: www.punchhotel.co.uk

25 The Rugby, No. 5 Dock Street, Hull, HU1 3DL, tel. 01482 324759

26 The Hull Cheese, Nos 39–41 Paragon Street, Hull, HU1 3PE, tel. 01482 228894

27 The Royal Hotel Hull, No. 170 Ferensway, Hull, HU1 3UF, tel. 01482 325087, website: www.britanniahotels.com/royal-hotel-hull

28 The Vauxhall Tavern, No. 1 Hessle Road, Hull, HU3 2AA, tel. 01482 320340

29 The Hop & Vine, No. 24 Albion Street, Hull, HU1 3TH, tel. 07787 564264

30 The Old English Gentleman, Mason Street, Hull, HU2 8BG, tel. 01482 324659

31 The Albion, Nos 19–20 Caroline Street, Hull, HU2 8EB

32 The Whalebone, No. 163 Wincolmlee, Hull, HU2 0PA, tel. 01482 327980, website: www.paul-gibson.com/history/the-whalebone-inn

33 The Bay Horse, Nos 115–117 Wincolmlee, Hull, HU2 8AH, tel. 01482 329227

34 Plimsoll's Ship Hotel, No. 103 Witham, Hull, HU9 1AT, tel. 01482 325995

35 The Polar Bear, No. 229 Spring Bank, Hull, HU3 1LR, tel. 01482 221113

36 The Botanic Inn, No. 231 Spring Bank, Hull, HU3 1LR, tel. 01482 610872

37 The Queens, Queens Road, Hull, HU5 2RG, tel. 01482 343541, website: www.queenshotelpub.co.uk

38 The Haworth Arms, No. 449 Beverley Road, Hull, HU6 7LD, tel. 01482 498951, website: www.greatukpubs.co.uk/hawortharms

39 Cannon Junction, Railway Arches, No. 366 Beverley Road, Hull, HU5 1LN, tel. 01482 474747

40 The Harry Pursey, No. 386 Beverley Road, Hull, HU5 1LN, tel. 01482 474181

41 The Gardener's Arms, No. 35 Cottingham Road, Hull, HU5 2PP, tel. 01482 342396, website: thegardenersarmshull.co.uk

42 Johnny Mac, Hull University Union, University House, University of Hull, Cottingham Road, Hull, HU6 7RX, tel. 01482 445361

43 The Goodfellowship Inn, Cottingham Road, Hull, HU5 4AT, tel. 01482 342858

44 The Four Alls, Cottingham Road

45 The West Bulls – Bricknell Avenue, Hull, HU5 4QD, tel. 01482 847497, website: stonehouserestaurants.co.uk

46 The Duke of Cumberland, Market Green, Cottingham, HU16 5QG, tel. 01482 847199

47 The Cross Keys Inn, No. 94 Northgate, Cottingham, HU16 4EH, tel. 01482 875364, website: www.crosskeys-cottingham.co.uk

48 The Half Moon Inn, No. 16 Main Street, Skidby, Cottingham, HU16 5TG, tel. 01482 843403

49 The Duke of Edinburgh, No. 1 Great Union Street, Hull, HU9 1UA, tel. 01482 225382

50 The Kingston Arms, No. 55 Thomas Street, Hull, HU9 1EH, tel. 01482 326376

51 The Whittington & Cat, Commercial Road, Hull, HU1 2SA, tel. 01482 327786, website: www.whittingtonandcat.com

52 The Hull Brewery Co. Ltd, Sylvester Street, Hull

53 Moors' & Robson's Breweries Ltd, Crown Brewery, Francis Street, Hull

54 Nellie's (The White Horse Inn), No. 22 Hengate Beverley, East Yorkshire, HU17 8BN, tel. 01482 86197, website: www.nellies.co.uk/

Further Reading

Books

Aldabella, P., *Hull & East Yorkshire Breweries*, East Yorkshire Local History Society, Hull, 1997

Allison, K.J. (ed.), *Victoria County History of the County of York and the East Riding. Vol. 1. The City of Kingston upon Hull*, Oxford, 1969

Barnard, R., *Barley Mash & Yeast, A History of the Hull Brewery Company 1782–1985*, Hull College Local History Unit, Hull, 1990

—, *Ale and Architecture: Four Old Town Pubs*, Hull College Local History Unit, Hull, 1996

—, *Moors' & Robson's Breweries Ltd: A Brief History*, Hull College Local History Unit, Hull, 1997

—, *The Old White Hart: Age and Myths*, 2nd ed., Hull, 1998

—, Rough Notes on Wincolmlee Pubs, Hull College Local History Unit, Hull, 1998

—, *The Minerva Hotel*, Hull College Local History Unit, Hull, 1999

—, *The Old Black Boy (1724–1999,) Revised Edition with Appendices*, Hull College Local History Unit, Hull, 1999

—, *The Albion Hotel: 19–20 Caroline Street: The Development of a Beerhouse*, Hull College Local History Unit, Hull, 2000

—, 'The Old White Hart, Hull', *East Yorkshire Historian 6*, 2005

Brandon, D., *Discovering Pub Names and Signs*, Oxford, 2010

Chrystal, P., *The Place Names of Yorkshire, including Pub Names*, Catrine, 2017

—, *Hull in 50 Buildings*, Stroud, 2017

—, *Historic England: Hull*, Stroud, 2017

—, *Old Yorkshire Country Life*, Catrine, 2017

Fuller, H.B., *Bottoms Up: A Walking Guide to Hull Pubs*, Beverley, 1993

Gamston, D. (ed.), *Yorkshire's Real Heritage Pubs: Pub Interiors of Special Historic Interest in Yorkshire and Humber*, CAMRA, St Albans, 2014

Gibson, P. and Wilkinson, G., *The Lost Pubs of Hull*, Kingston Press, 1999

Gibson, P., *Hull Pubs and Breweries*, Stroud, 2004

Gleadow, R.W., *Hull Brewery Horses*, Hull, 1971

Haydon, P., *The English Pub: A History*, London, 1994

Hull Brewery Company Ltd, *Illustrated History of the Hull Brewery Company Limited*, Hull, 1960

Jackson, G., *Hull in the Eighteenth Century: A Study in Economic and Social History*, Oxford, 1972

Ketchell, C., *The History of Spring Bank*. Hull College Local History Unit, Hull, 1996

—, *The History of the Tap & Spile Spring Bank Hull*, Hull, 1997

—, *The Polar Bear, the Museum, the Pyrotechnist and the Pub: A Brief History of the Polar Bear Public House*, Hull College Local History Unit, Hull, 1993

Markham, J., *The Streets of Hull: A History of their Names*, Beverley, 1987

Miles, P.C., *Yesterday's Hull*, Clapham, 1989

Neave, D., *Pevsner Architectural Guides: Hull*, New Haven, 2010

Pepper, B., *A Haunt of Rare Souls*, Otley, 1990

Pevsner, N., *The Buildings of England: Yorkshire – York and the East Riding*, 1995

Websites

www.paul-gibson.com/pubs-and-breweries/the-wellington-inn.php

www.paul-gibson.com/pubs-and-breweries/the-whalebone-inn.php

www.paul-gibson.com/pubs-and-breweries/lost-pubs-of-hull

www.paul-gibson.com/pubs-and-breweries/spring-bank-pubs.php

www.paul-gibson.com/pubs-and-breweries/beverley-pubs-w-to-z.php

www.rbarnard.karoo.net/King%20Billy.pdf

http://yeoldeblackboy.weebly.com/history.html

https://davelee1968.wordpress.com/2010/05/29/pub-of-the-week-the-whalebone-hull/

The Landlord by F. W. Elwell (1870–1958) in Ferens Art Gallery, Hull.